TUNA MELTS MY HEART

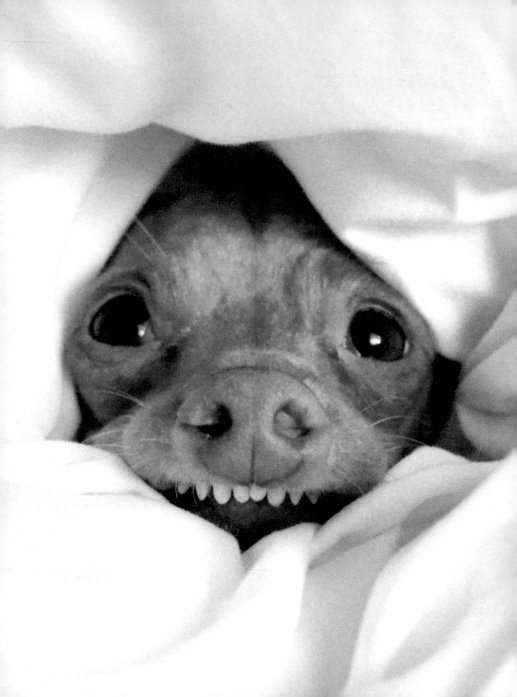

TUNA MELTS MY HEART

THE UNDERDOG WITH THE OVERBITE

COURTNEY DASHER

 NEW AMERICAN LIBRARY

New American Library
Published by the Penguin Group
Penguin Group (USA) LLC, 375 Hudson Street,
New York, New York 10014

USA | Canada | UK | Ireland | Australia | New Zealand | India | South Africa | China
penguin.com
A Penguin Random House Company

First published by New American Library,
a division of Penguin Group (USA) LLC

First Printing, March 2015

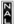

REGISTERED TRADEMARK—MARCA REGISTRADA

LIBRARY OF CONGRESS CATOLOGING-IN-PUBLICATION DATA:
Dasher, Courtney.
Tuna Melts my Heart: The Underdog with the Overbite/Courtney Dasher.
p. cm.
ISBN 978-0-451-47584-8 (paperback)
1. Dogs—Humor. 2. Dogs—Pictorial works. I. Title.
PN6231.D68D365 2015
818'.602—dc22 2014042248

Printed in the United States of America
10 9 8 7 6 5 4 3 2 1

Set in Electra LT Std
Designed by Alissa Rose Theodor

To every person who has ever rescued an animal in need.

Thank you.

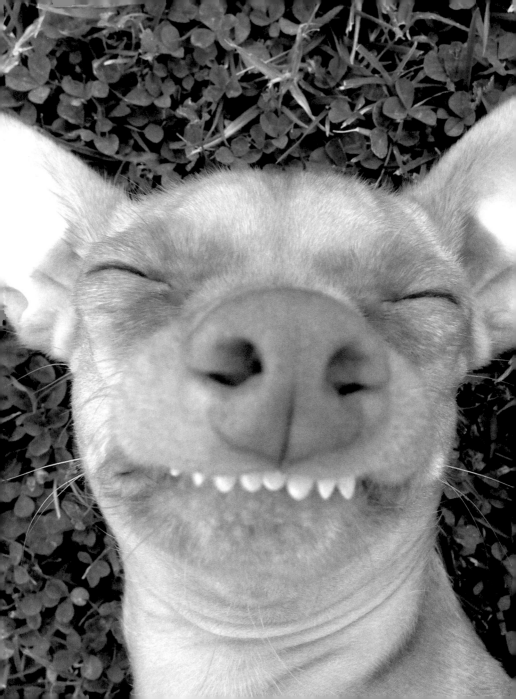

CONTENTS

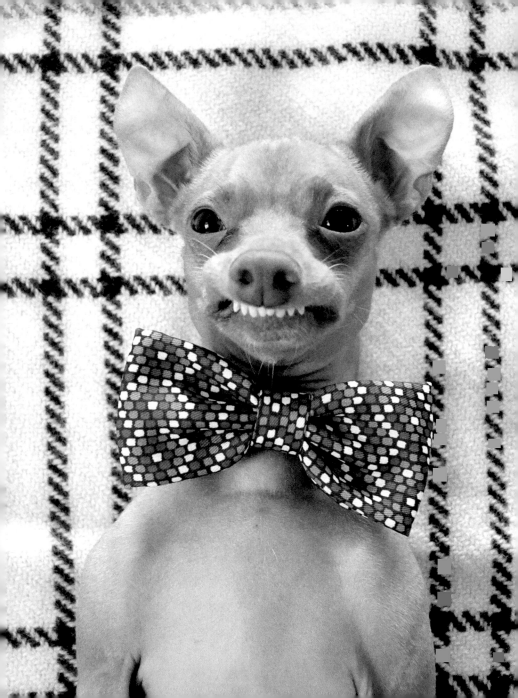

INTRODUCTION

This is the story of a fine young sir named Tuna. While most Tunas that you know are probably fish, this particular Tuna is actually a dog. His name is derived from the word "cartoon," since he has an uncanny resemblance to Montgomery Burns of *The Simpsons*.

Tuna's cartoonish looks are one thing that sets him apart from his other furry friends. He was born with an exaggerated overbite and a recessed lower jawline, which give him his distinguished shrivelneck and a one-of-a-kind profile.

Much like his endearing physical attributes, Tuna is unconventional in every way. He has the ability to melt your heart with just one glance, and he will teach you that true beauty comes in all forms and radiates from within. The more you learn about him, from his beginnings as an orphan dog to his current role as an ambassador for animal rescue, you will begin to fall in love with him.

I first met Tuna when he was a four-month-old puppy, in December of 2010, at a farmers' market in Los Angeles. A year into our friendship, I created an Instagram account dedicated to Tuna's photos, and at the end of 2012, Tuna's notoriety grew on Instagram when they featured a picture of him on their personal page, unbeknownst to me.

I never anticipated the kind of response that I've received from people all over the world who adored Tuna. In fact, when I created his account, I had no agenda. I had no desire to garner a large following; it wasn't about building followers or building a platform. I recognized that Instagram could be a catalyst to bring people joy through Tuna's pictures by showcasing his cartoonish looks and his charming personality. That has proven to be true. He spreads joy and love, and inspires people daily. I constantly receive countless comments and e-mails about the impact that Tuna is making on their lives.

Since Tuna is the epitome of the underdog, most people advocate for him and adore him

for his endearing qualities. His loyal followers embrace his physical differences, have fallen in love with his charm, and connect to his message.

Within these pages you will find an endearing love story about the bond between me and my sweet rescued pup. I spend a lot of time writing about Tuna's activities and commenting on his loving personality traits and quirks. And now I'm inviting you into a day in the life of Tuna.

This book is designed to bring you joy through an intimate look inside his world—an underdog perhaps, but one that has brought so much love and laughter into my life and into the lives of his followers throughout the world.

GLOSSARY OF TERMS

Shirvelneck: an exaggerated, wrinkly neck consisting of multiple folds.

Toodlebrain: a term of endearment that I use to describe Tuna's quirky personality.

Old Colin: a tattered doll from Monster Factory. Old Colin is Tuna's original best friend. I accidentally left him at a park, but he was later returned after I posted a sign about his disappearance.

New Colin: a replacement Monster Factory doll. Tuna's other best friend.

The Tree: a game that we play where Tuna wrestles my hand. It's been dubbed "The Tree" because my fingers resemble the branches and my forearm is the trunk.

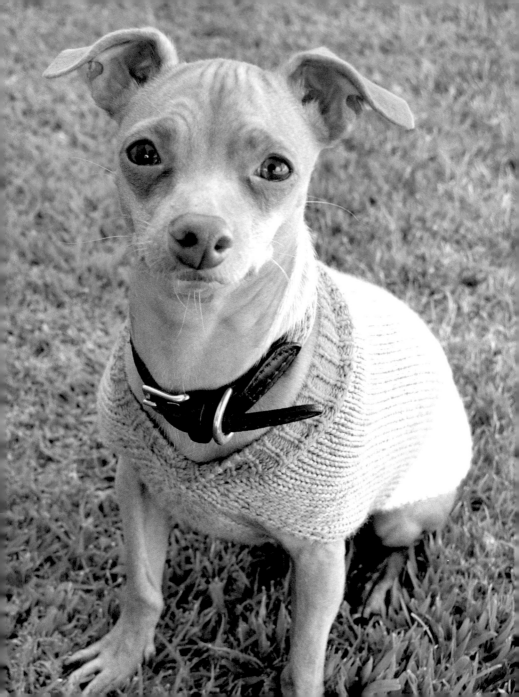

CHAPTER 1

WAKEY WAKEY

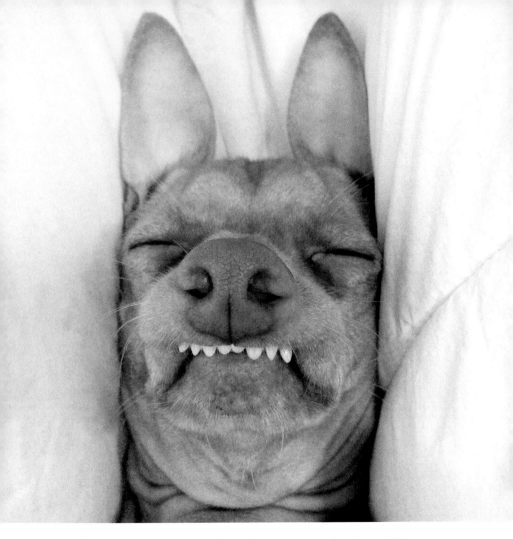

Good morning, Tuna! I realize that you must be incredibly comfortable lying there in the covers. Trust me, guy, I really hate to disrupt your slumber, but it's time for you to get up.

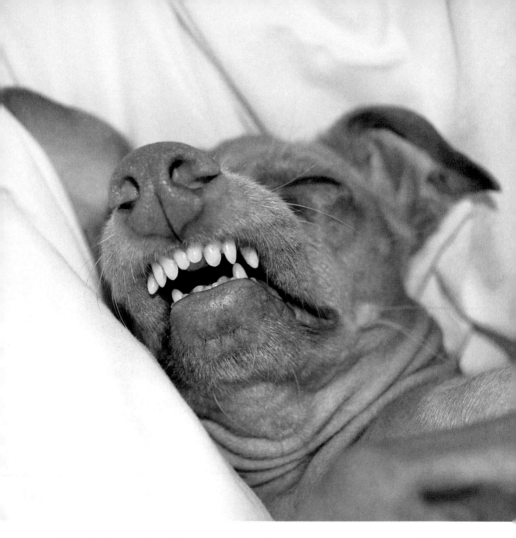

This is just a friendly suggestion, but you may want to consider shutting your mouth a little. Otherwise, you're going to let a fly in there.

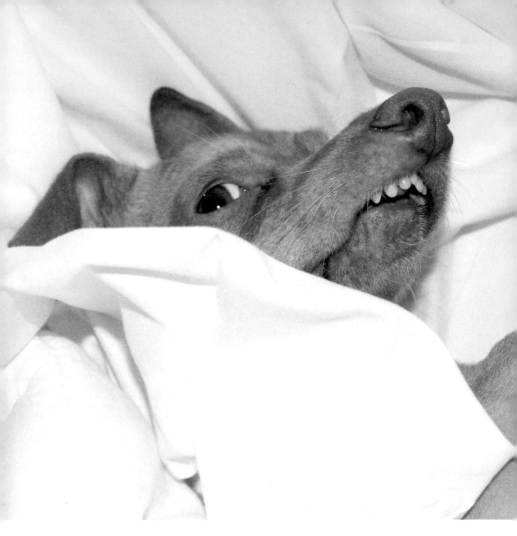

Aaah, yes! I knew that if I mentioned your buzzing winged enemy, the fly, you would wake up immediately.

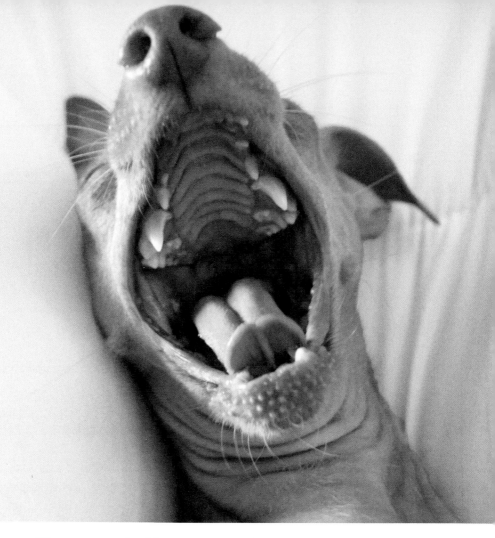

There you go, buddy! Yawn it out, but I hope you realize that now you have completely granted full access to allow any types of pesky insects inside your mouth.

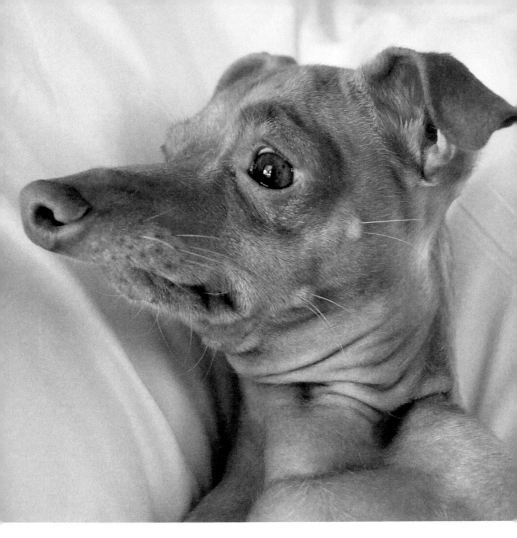

Sir! For Pete's sake. I'm over here. I literally just need a moment of your time. I mean, honestly.

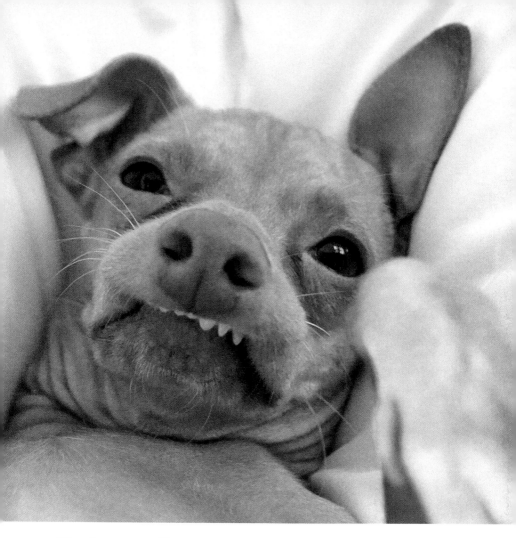

Thank you. I really appreciate the good eye contact, but your shrivelneck is distracting me a little. P.S. Slouching isn't great for your posture, so maybe sit up a bit straighter.

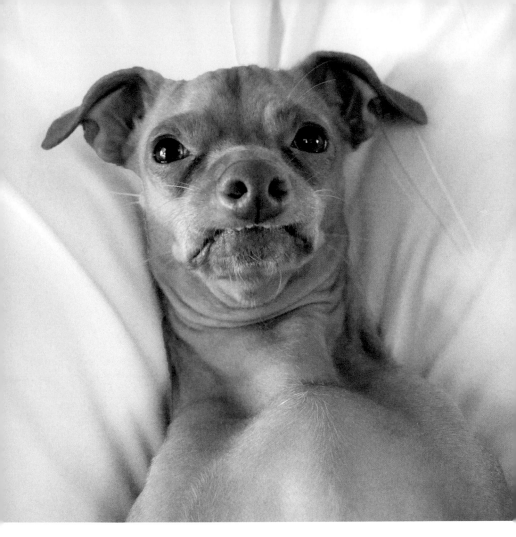

That's much better. Now that I have your undivided attention, I was just saying that you have a full day ahead of you, and all that you have to do is be your awesome self.

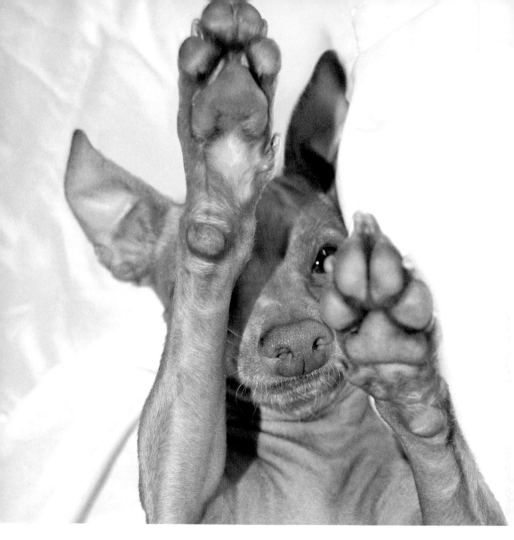

Perhaps a quick photo session before we get started, though? Just kidding! You can put your paws down now, sir. I'm saving that for a little later.

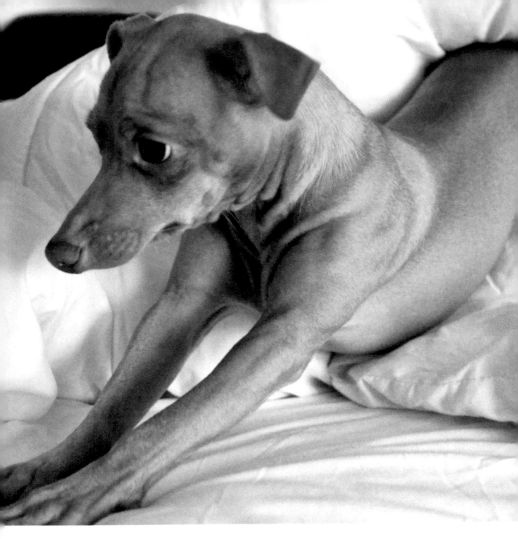

All right, guy. Take a few minutes to practice your downward dog, but when you've wrapped that up, please go pick out one of your stylish sweaters so that we can get you dressed for the day.

CHAPTER 2

OLD COLIN

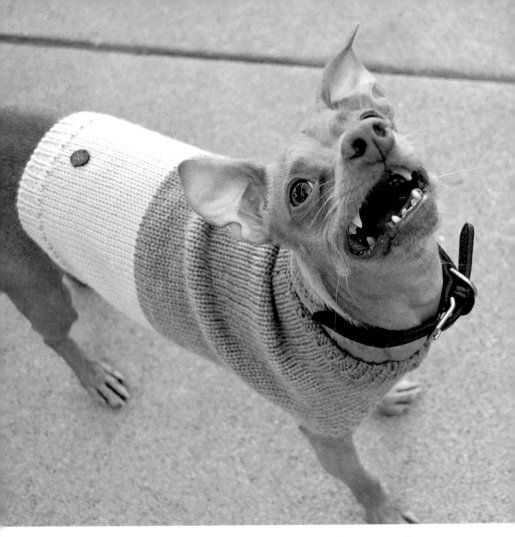

Bowchickawowwow! Someone certainly looks devastatingly handsome in that sweater. Now that you're dressed to impress, how about we go play with the original gangsta, Old Colin?

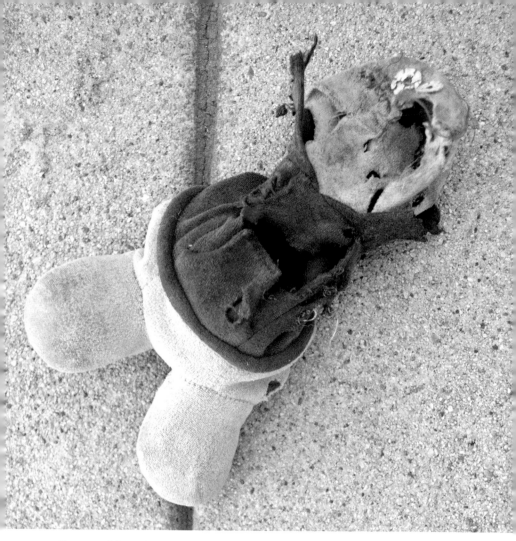

Geez! Old Colin is a mess! Remember when I left him at the park a few years ago? He was in much better shape then. Oh, shoot. I never told you about that incident, did I? Well, haven't you ever wondered why you have an Old Colin and a New Colin?

HAVE YOU SEEN THIS GUY?

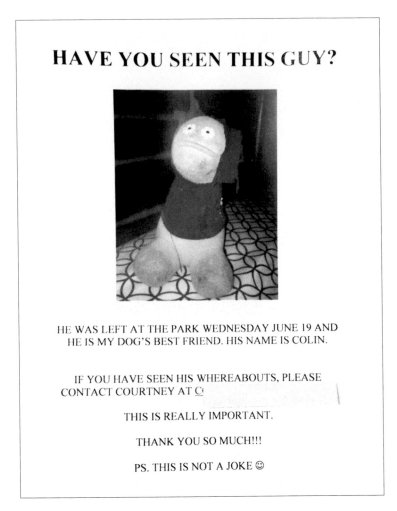

HE WAS LEFT AT THE PARK WEDNESDAY JUNE 19 AND
HE IS MY DOG'S BEST FRIEND. HIS NAME IS COLIN.

IF YOU HAVE SEEN HIS WHEREABOUTS, PLEASE
CONTACT COURTNEY AT C

THIS IS REALLY IMPORTANT.

THANK YOU SO MUCH!!!

PS. THIS IS NOT A JOKE ☺

A few years ago, I accidentally left Colin at the park. I searched
high and low, but he was nowhere to be found. I ordered you a
replacement right away since I knew how much you loved your
best friend, but I wasn't sure if you would accept the new guy. So
I posted a missing persons sign in the park with hopes that
someone would return him. A little crazy, isn't it?

I have Colin

June 21, 2013, 5:18 PM

Hi! My Golden retriever Bronze picked
your dogs toy in the park a couple days
He wouldn't let it go so I let him carry it
with us. So Colin is safe at my place. C

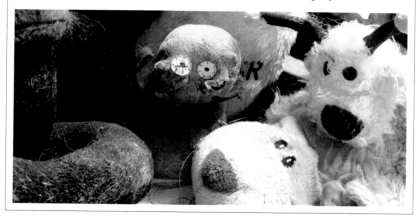

Well, to my relief, it actually worked! Two days later, I was
contacted by a wonderful woman who explained to me that her
Golden Retriever Bronze brought Colin back from the park.
Colin could have been a goner, but lucky for you, Bronze is a
retriever and a returner.

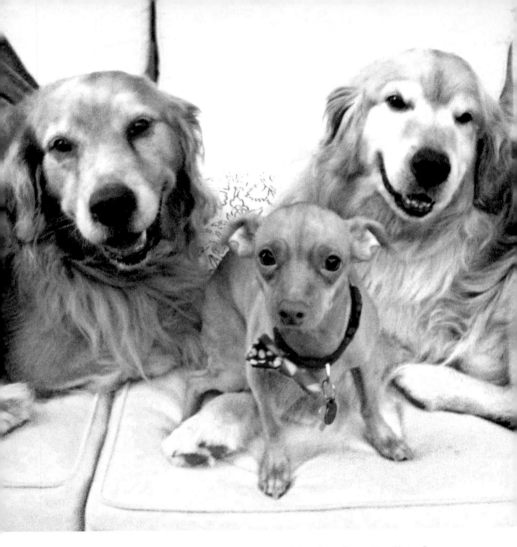

Wait a sec! We hung out with him and his brother, Bodhi, that day. Bronze returned Colin to you. Is it all making sense?

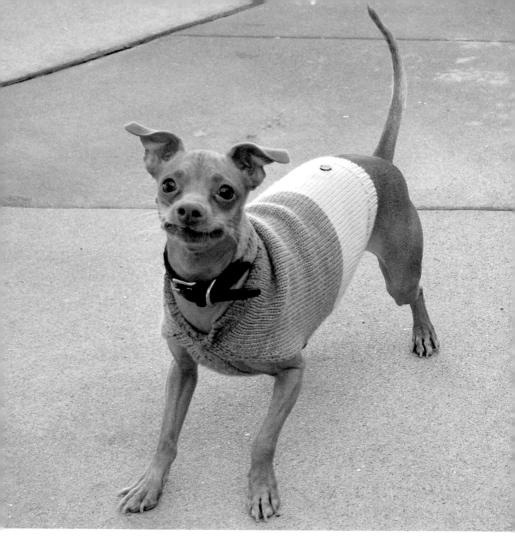

Now that you know the story of how I almost lost Old Colin, you must be dying to play with him. The look of anticipation on your face is priceless, Tuna, so let's not waste any more time. Go get him!

Excellent job, buddy, but can I make a suggestion? Maybe consider pumping the brakes a bit because it looks like you're in the middle of ruining Old Colin's life . . . more than it already is, if that's even possible.

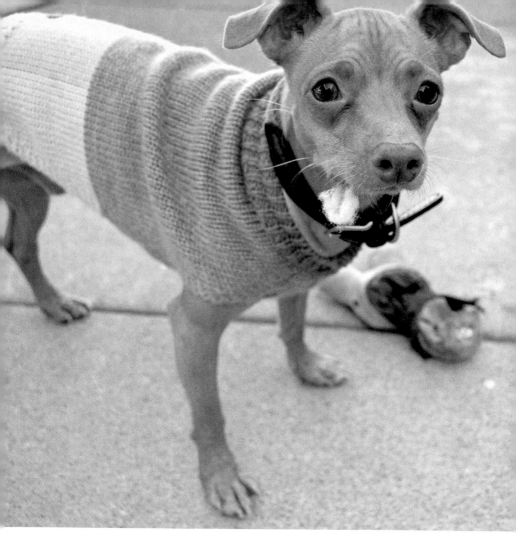

Excuse me, sir, but you may want to take a quick look in the mirror because you definitely have remnants of Colin on your face. That or you're suddenly turning into Santa Claus.

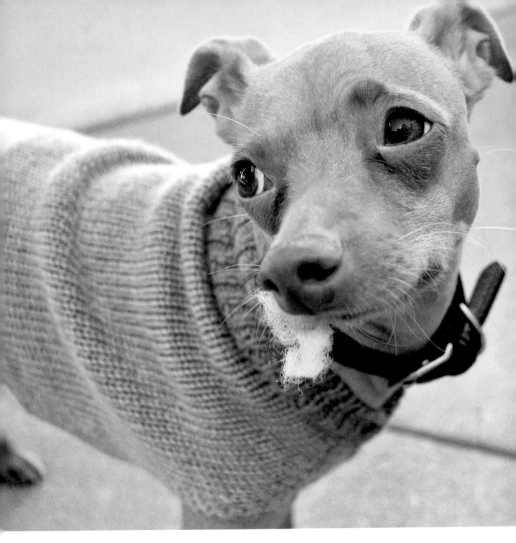

For goodness' sake, man. No need to look so self-conscious. It's only cotton stuffing, not a real fuzzy white beard, so it can easily be removed. Here, let me get that for you.

CHAPTER 3

NAKEY NAKEY

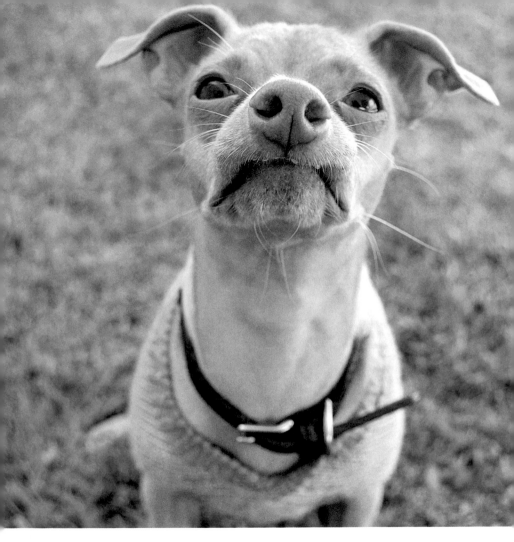

I get a feeling that there is something you are trying to tell me, but unfortunately I don't speak Doglish. Perhaps you can just show me. Let's play charades.

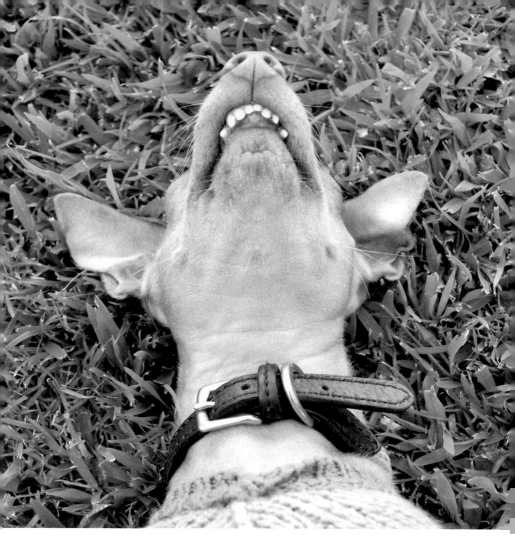

Oh, I see. You're completely wiped out from all of that roughhousing with Old Colin. Well, how about you take some time to relax while I go into the house to prepare you a delicious lunch?

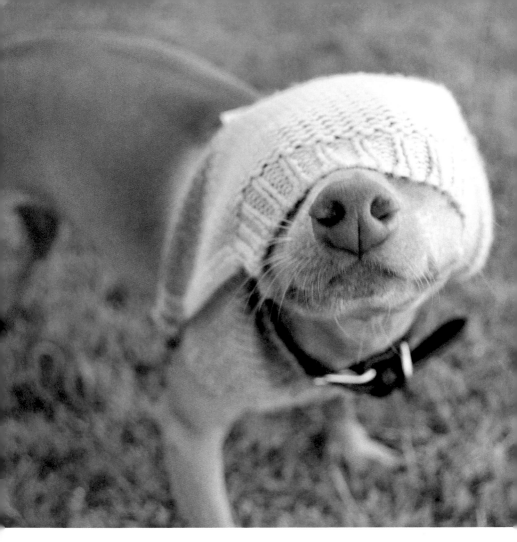

Sir! What in the actual heck are you doing? I was literally gone for five minutes. I would have totally helped you out with this whole situation, but I see that you've taken matters into your own hands, eh-hm, I mean, paws.

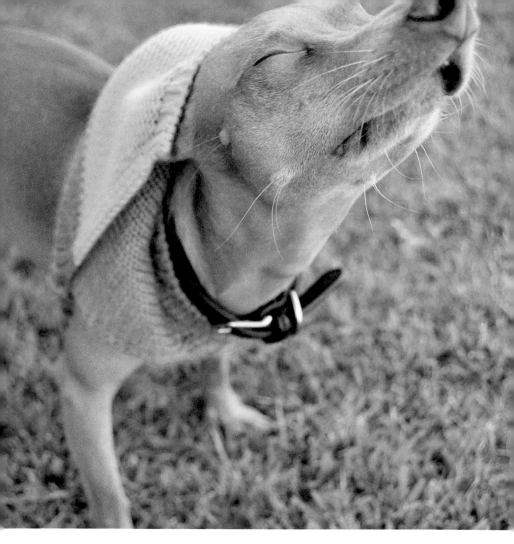

This is getting a little ridiculous. I realize that you want to be self-sufficient and all, which is totally admirable, but you might want to let someone with actual thumbs help you out, i.e., me.

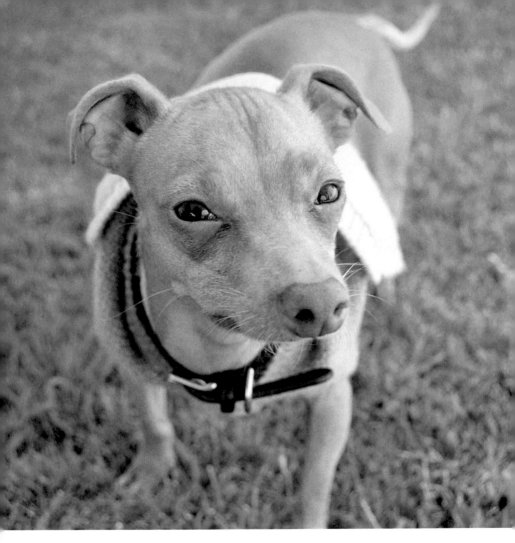

Have you finally decided to surrender? It's perfectly okay to admit that undressing yourself isn't your forte. Don't feel bad about it or anything. You have a lot of remarkable strengths in other areas, like . . .

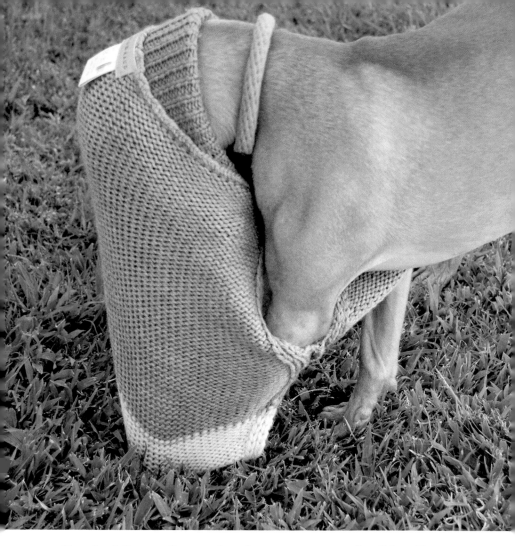

Good grief, man! I guess I spoke too soon. You should really see yourself. You look like a hot mess all tangled up in that sweater.

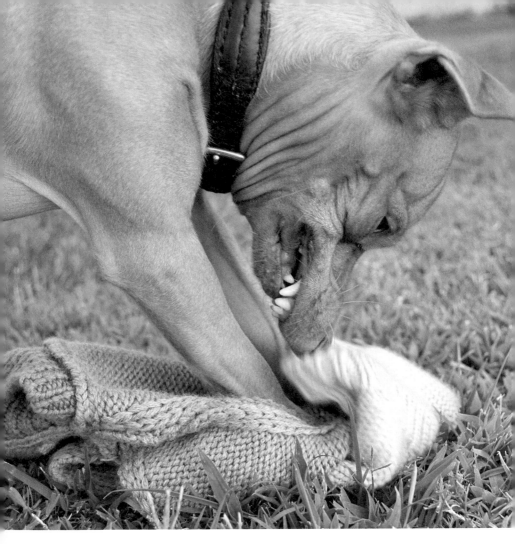

SIR! For goodness' sakes! Completely unacceptable. This is actually a really delicate sweater, so it's not the best idea to tear it to shreds. Please let it go, and paw it over.

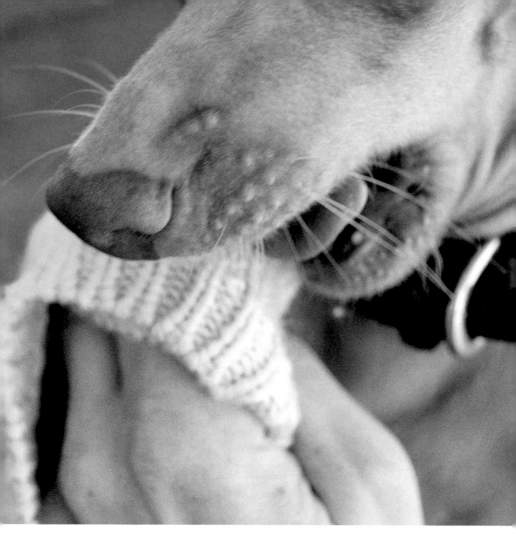

Haven't you ever heard of the expression "Don't bite the hand that feeds you"? Or in this case, the hand that's holding your really nice sweater? I mean, if you want to bite my hand, why don't we lose the sweater and play "tree" for a bit?

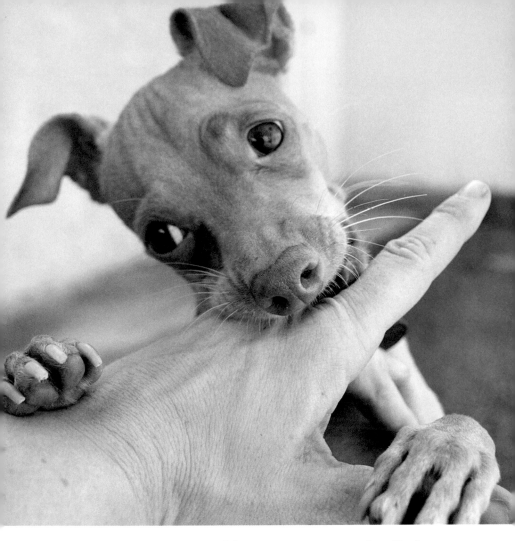

Now, with the sweater out of the picture, you can take all of your aggression out on my hand. Just be careful not to bite it off because I'm going to need it, especially to take photos of you later. Let's not forget about that photo shoot that we have planned.

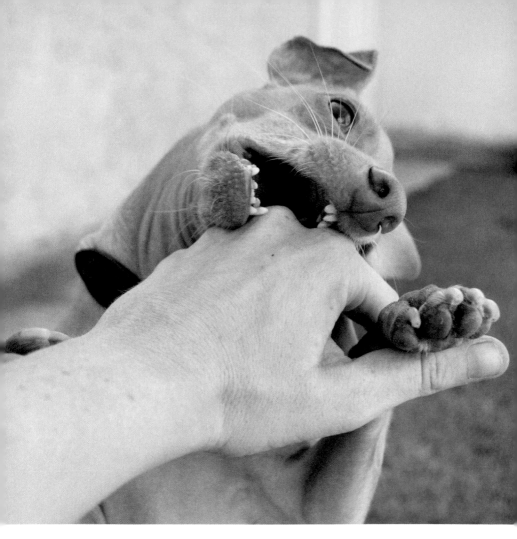

Apparently you didn't hear me, sir. I'm going to need my hand. While you have full permission to play bite, this is just a friendly reminder that you actually have really sharp teeth, so . . .

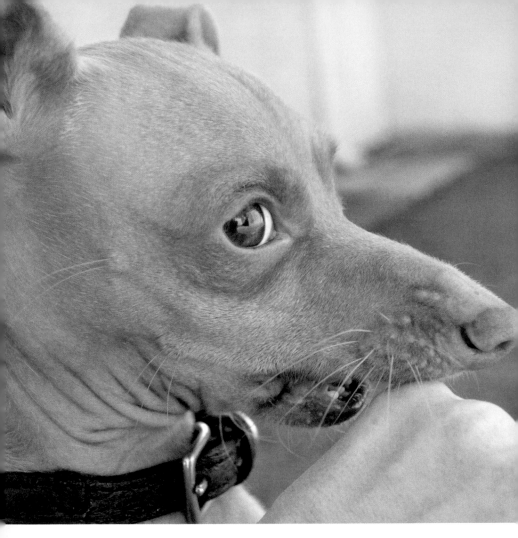

Hey. No need to give me that look of shame. I know your intentions aren't to be aggressive, so it's all good, buddy. No hard feelings.

CHAPTER 4

SO FLASHY

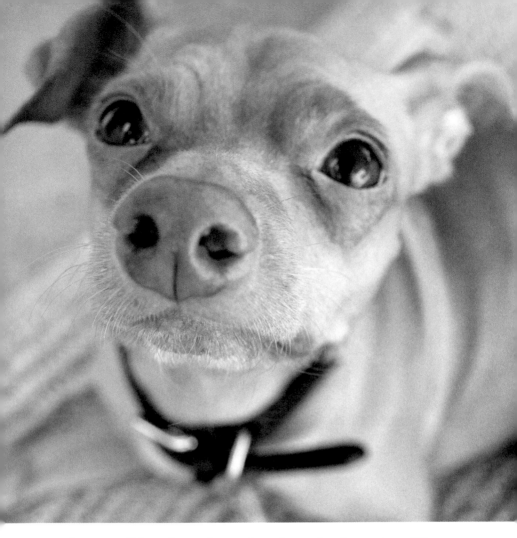

Today we will be taking photos for a fun calendar project! We are going to have a blast like we always do, so let's grab your costume box and get started!

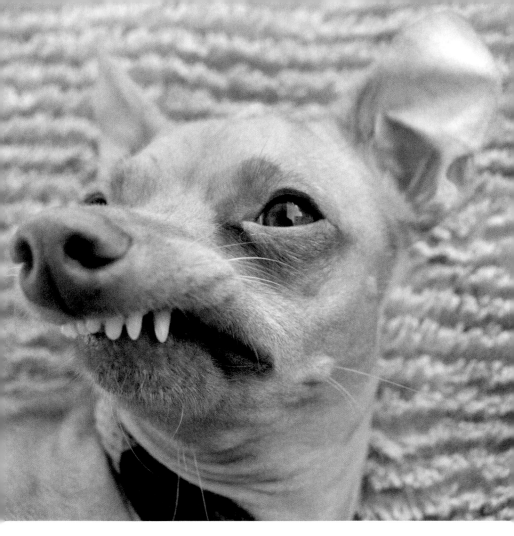

Good thinking! You should definitely get your best "blue steel" face ready. Nice try but you may want to keep practicing. You almost have it!

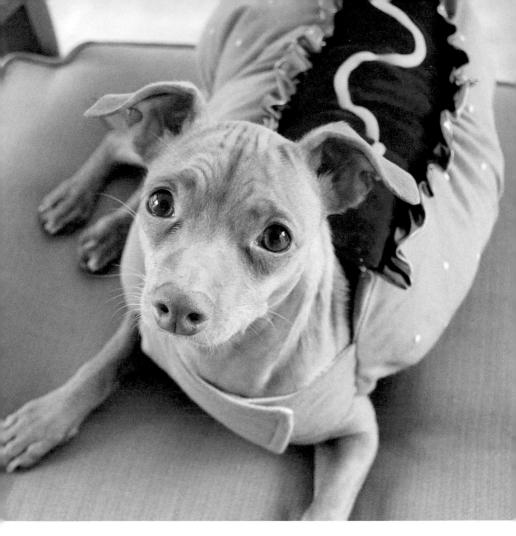

This is going to require you to dress up in some ridiculously embarrassing, yet festive outfits . . . kind of like the one that you are currently wearing. While I realize that may not be necessarily "festive," it is appropriate given you're half weiner dog.

What? You're not feeling this one? Do you think it's too "Look at me. I'm a Leprechaun"? OK, I agree. Well, how about we "spice" things up a bit then? I have just the costume in mind!

Yes! This one's the perfect complement to your name, Spicy Tuna, and the hat's a nice touch. Wasabi and soy are a must!

Apparently you disagree since you ditched that hat. Well, don't just stand there, Spicy Tuna. How about you "roll" on over here so we can get you into a different costume? Pun definitely intended!

How about this one? Do you get it? You're Bumblebee Tuna . . . like the canned fish. Holy smokes! This costume just gave me a brilliant idea for the next one.

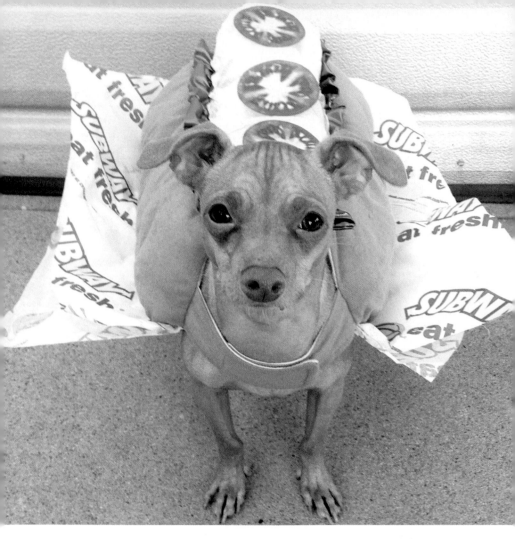

Well, don't you look delicious! You're hands down the tastiest-looking tuna sub sandwich that I've ever laid eyes on, which is saying a lot. You've managed to make whipped tuna salad look appetizing!

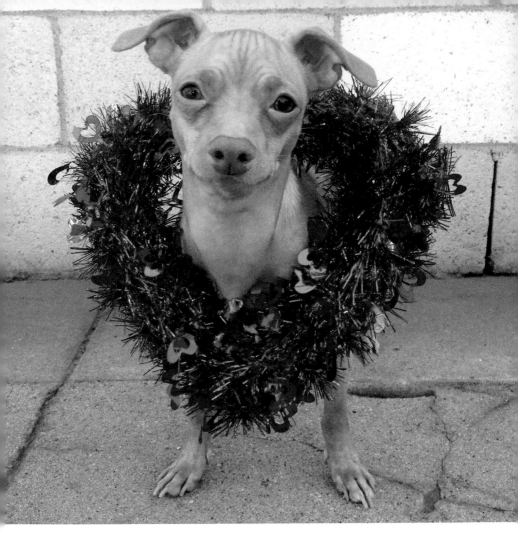

If this isn't a true depiction of you being a heart melter, then I don't know what is. I feel like we could jazz up this Valentine's Day concept a little bit more, though. How about we grab a satin bow tie and get a tad more imaginative?

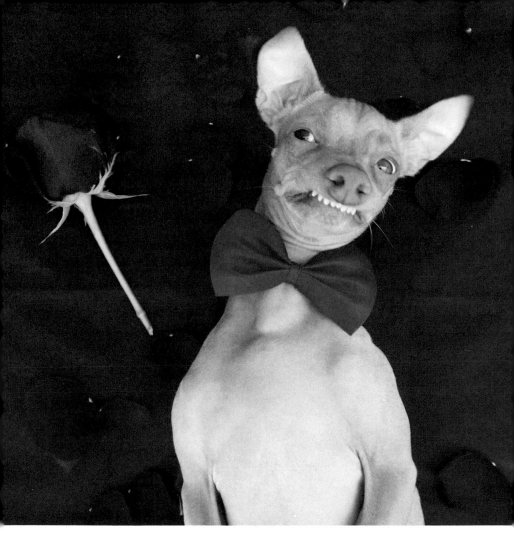

Now, that's what I'm talking about! You look so handsome and sultry! Like a true Casanova. And that seductive smizing is a nice touch and will certainly melt a few hearts. Speaking of melting, for the next scenario, you'll just be relaxing under the sun.

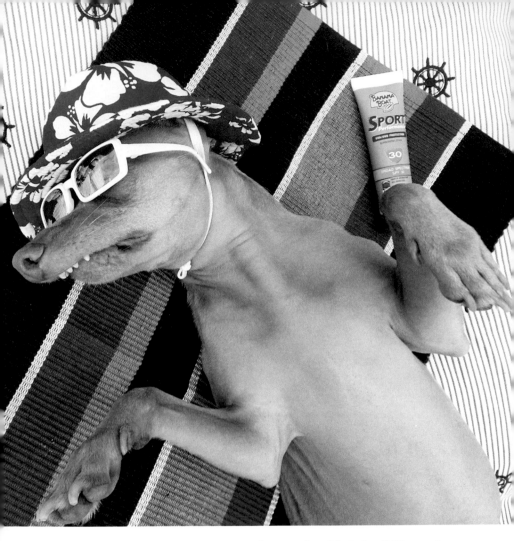

Sir, someone with your fair complexion shouldn't be falling asleep in the sun. Unfortunately, that sunblock lying next to you is only a prop, so you should really consider covering up.

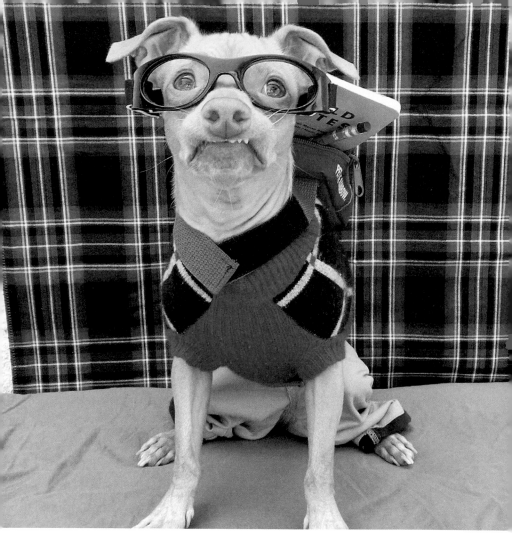

A T-shirt would have been sufficient, but you went to the next level! Straight to the fall! I'm really liking the schoolboy uniform coupled with the plaid. You look like you stepped off the pages of a prep school yearbook!

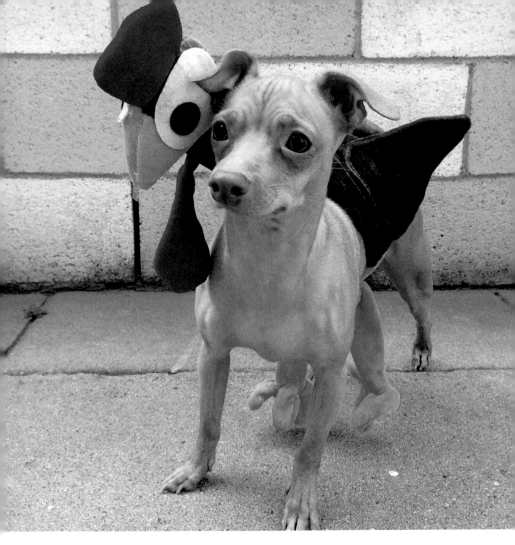

Okay, so for this one, I'm going to need you to make better eye contact with the camera and tilt your head to the left a bit more because your right ear is upstaging your co-model, Gary. He keeps complaining about it.

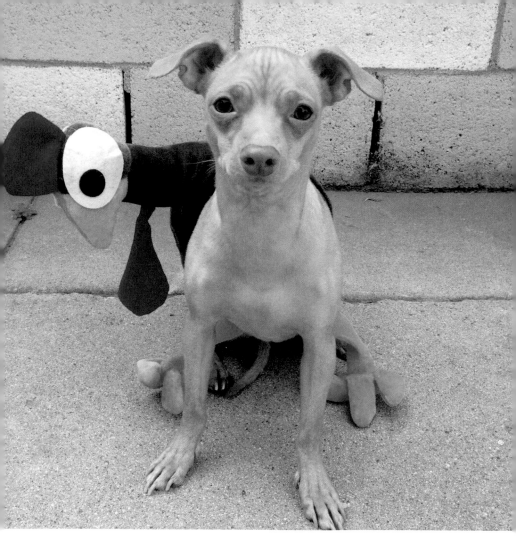

That's not exactly what I had in mind. It looks like you and your buddy could use an energy drink. That or a nap, because you've plopped down and he's falling asleep on the job. That's not very professional, guys.

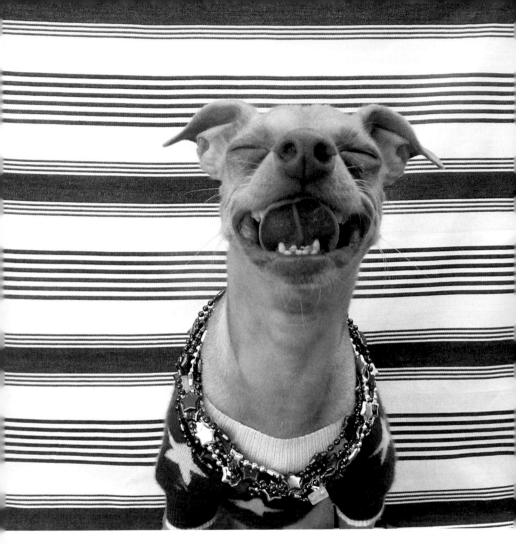

A true patriot is devoted to his cause, and while I really appreciate you giving your best to this final photo, you can hardly keep your eyes open, sir. Apparently someone is long overdue for a nap, so it's time to retire!

CHAPTER 5

~~CAT~~ DOG NAP

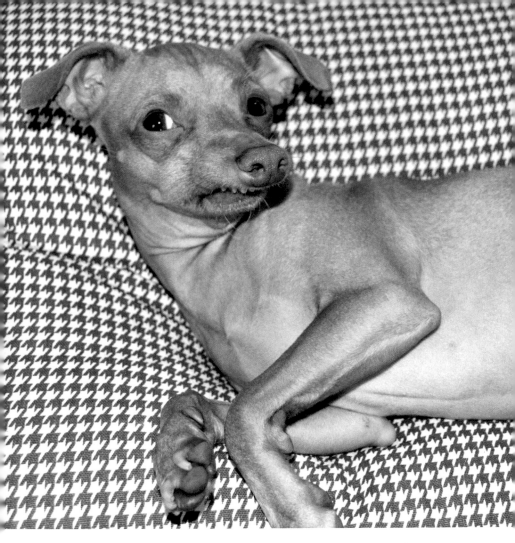

The look of agitation really isn't necessary, sir. I realize that it's impossible for you to fall asleep without your cozy blanket, but all you have to do is ask nicely, and I'll bring it over to you right away.

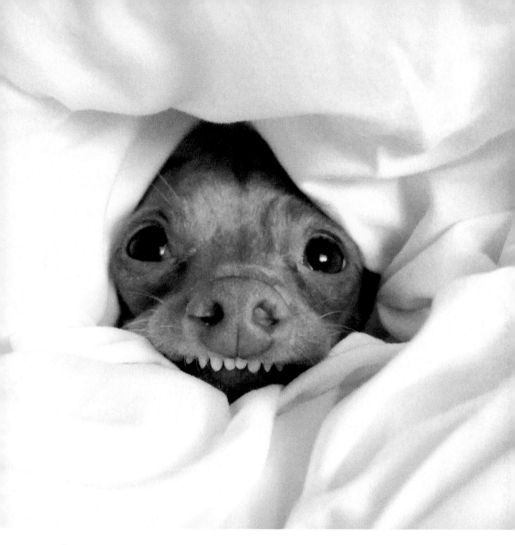

That's more like it. You'd much rather be bundled up like a burrito. It must be the Chihuahua in you. OK, now it's time for you to get your beauty sleep, little one!

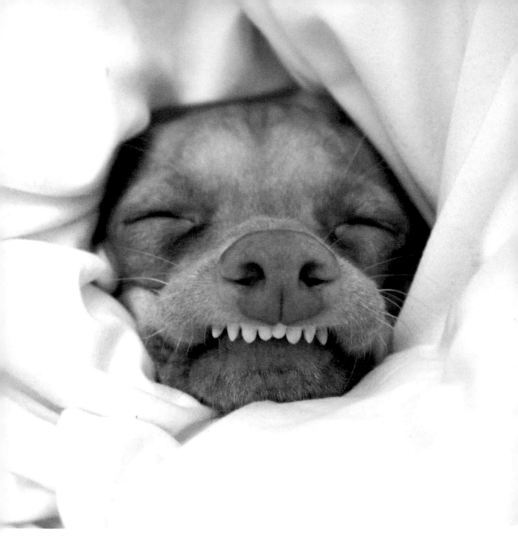

See, the beauty sleep is already working because you look really pretty right now! I'm going to credit it to that signature smile of yours. You could totally be a Crest model! Seriously!

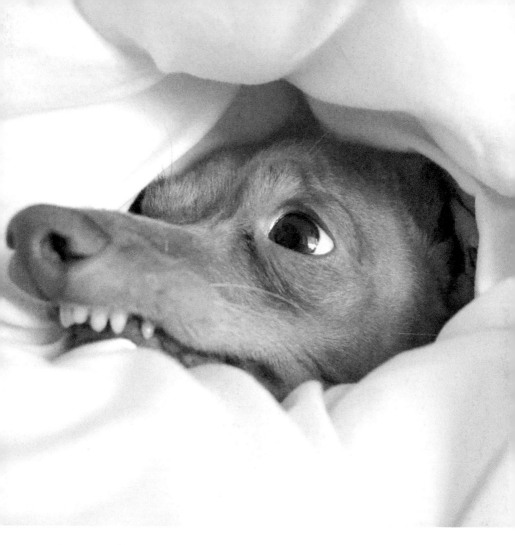

Dang it. I knew I shouldn't have mentioned toothpaste. Sometimes I forget how much you loathe getting those pearly whites brushed.

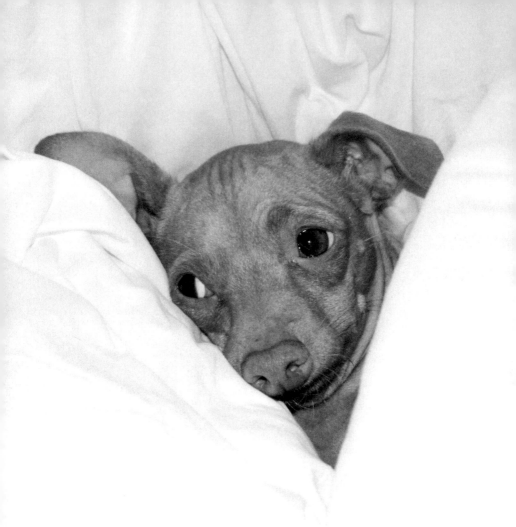

Hey, now. There's no need to conceal your grill. Brushing may not
be necessary unless you decide to eat a ton of cookies later, which,
knowing you, is 100 percent bound to happen. We'll just cross
that "bridge" when we get to it. Pun intended.

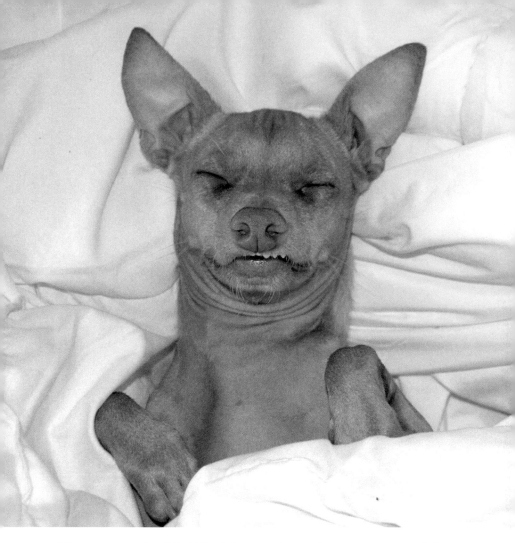

There you go, buddy. Much better. I can almost see some of those little teefers trying to peek out again.

Ugh, my heart! Honestly, guy. Can you be any cuter while you sleep? Seriously. It's borderline inappropriate how adorable you are.

CHAPTER 6

NEW COLIN

Hello, sweet pea. Looks like someone may have woken up on the wrong side of the bed. How about you take a few moments to cuddle with your other bestie, New Colin?

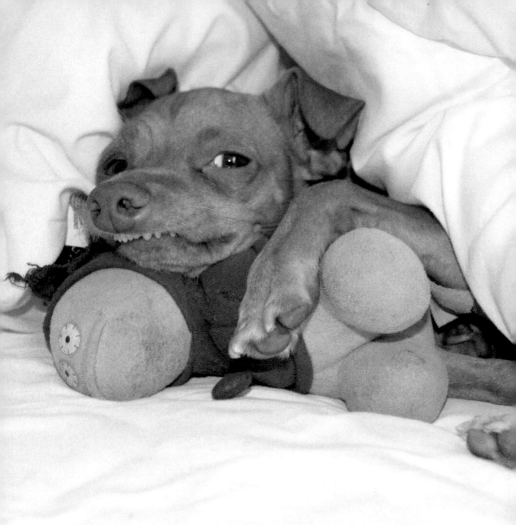

On second thought, New Colin is on the verge of being banned from sleeping in my bed with you, per his filthy exterior. He's really starting to resemble Old Colin, which isn't anything to be proud about. They could almost be twins!

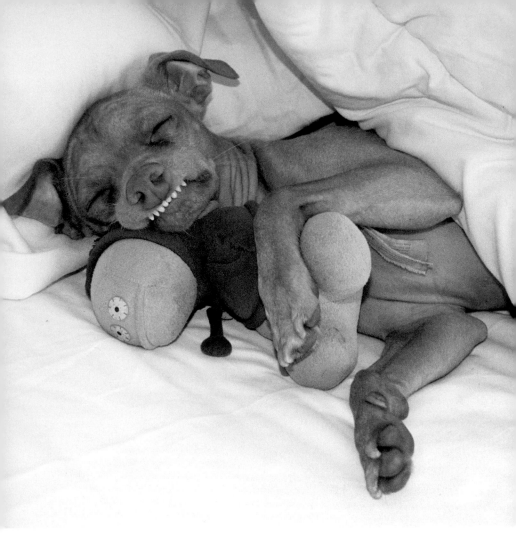

Um, excuse me, sir. I hate to interrupt your spooning session, but falling asleep again is not an option. It's time to get up and play with him.

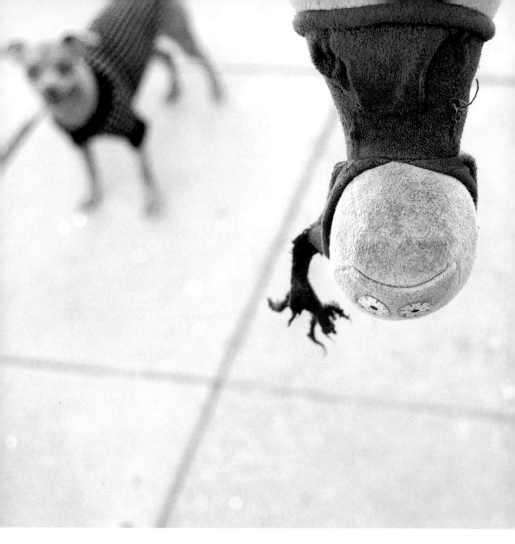

It astonishes me that this guy is your replacement Colin. I mean, we literally just left the house, and he's already missing his other arm! I guess that's what happens when you're well-loved.

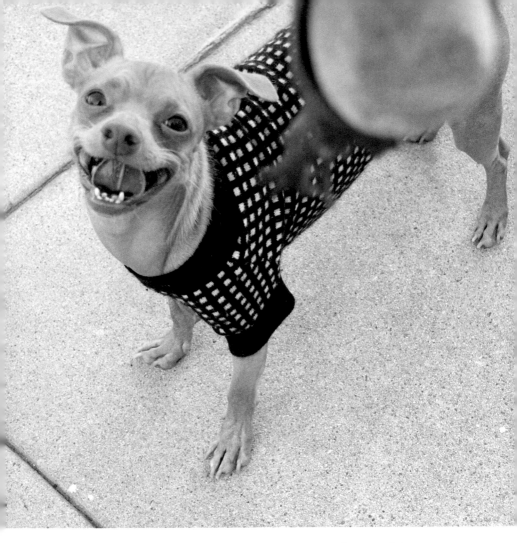

So are you ready to "love" on him even more, aka, tear him to shreds? It certainly looks like you're anticipating that because you have the biggest grin on your face, and that's a dead giveaway.

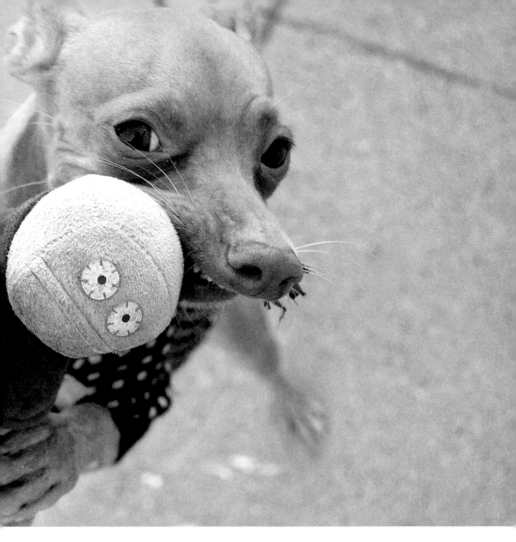

Colin on the other hand doesn't look too thrilled about his inevitable fate. I bet he's wishing he could trade places with Old Colin, who is probably lounging in bed right about now.

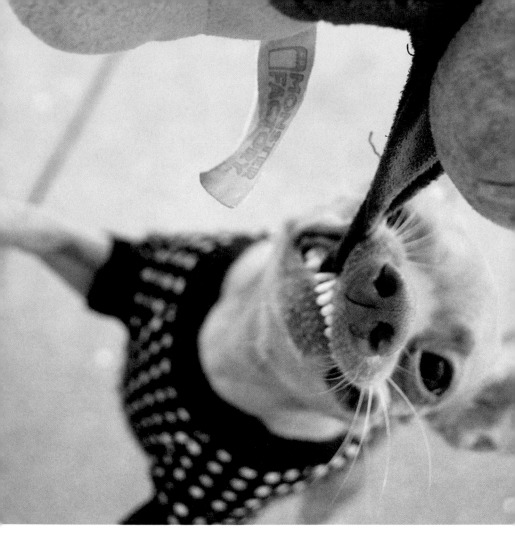

Holy smokes! You've got some really aggressive tug-of-war skills. You may want to consider going a little easier on him, or New Colin is going to end up in tatters like the other Colin in no time.

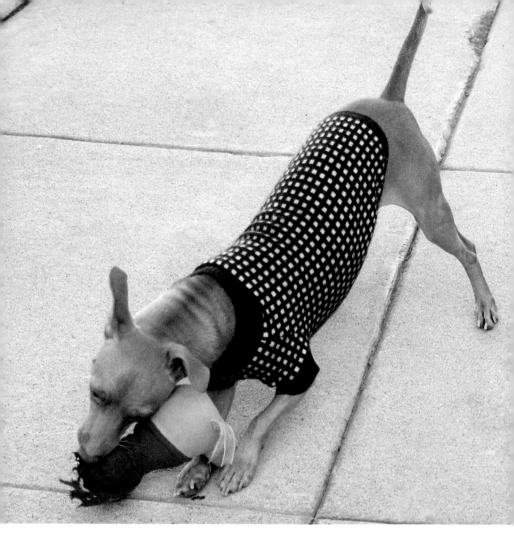

Welp! You've pinned him! Clearly you're strong, but no, you cannot take up professional wrestling. Besides, your muscles aren't really that big anyway. I'm just being honest.

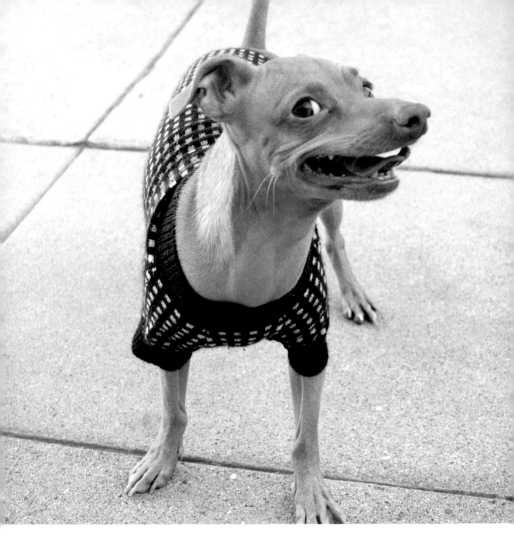

Wow. You look really accomplished, and also, a little hot and sweaty. How about we lose the sweater and go au naturel for our next activity?

CHAPTER 7

CRUISIN'

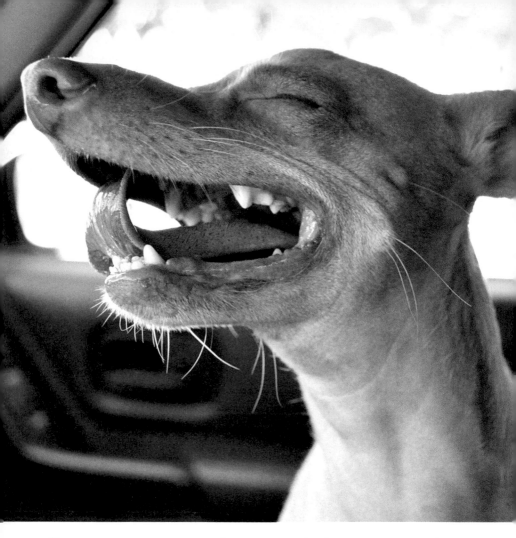

I'm not naming any names, but someone looks pretty overjoyed to be going for a car ride.

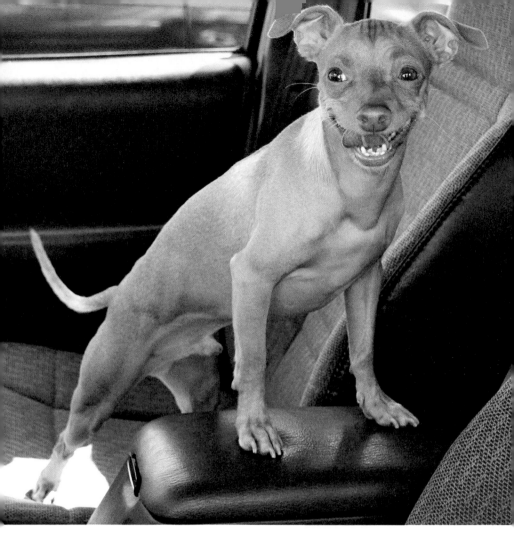

I haven't even told you where we are going yet, but I'll give you a clue. It's a five-letter word that begins with a B and ends with EACH.

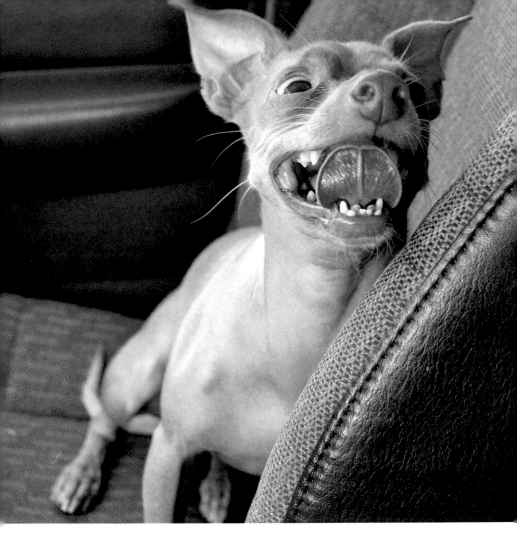

That's right! You guessed it! The beach! Clearly you're loving that idea because you have the most fantastic, crazy grin splattered across your face.

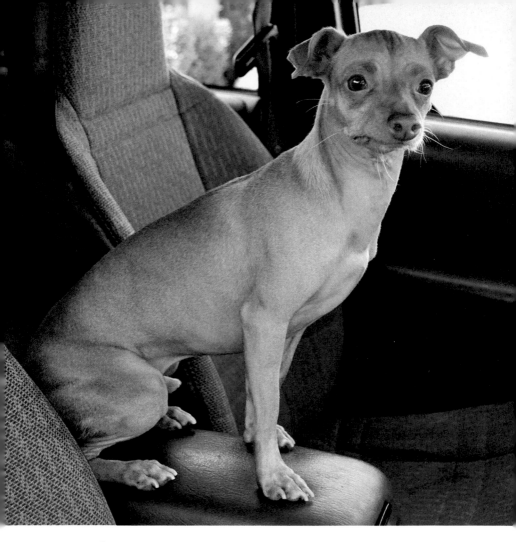

First, I have to run into the dry cleaner. By all means, sit up on
the console since you like creeping on me while I step inside.
There's really no need to look so forlorn because I'll be right back!

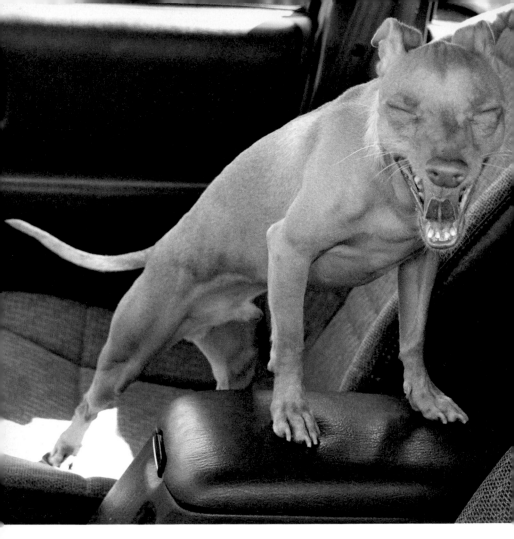

Well, good grief, man. I was only in there for, like, a minute, and you're already yawning? We have too many fun adventures planned for you to be falling asleep on me. How about you get in the backseat while we drive?

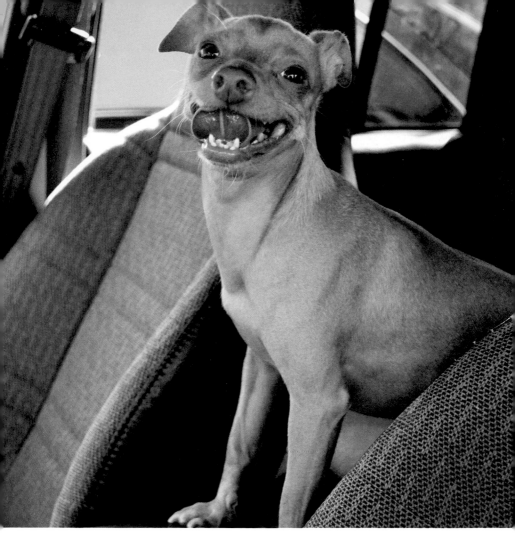

Sir. As cute as you may be, your good looks aren't going to win this battle for you. I meant all the way in the back, not partially in the back. There's a big difference between the two, just so you know.

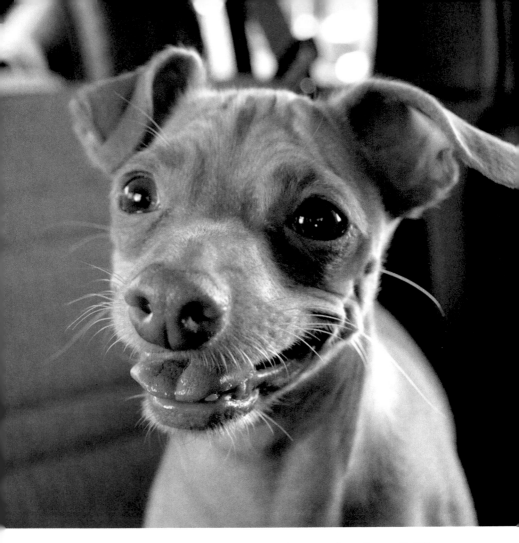

Here, put this on. I had your favorite bow tie dry-cleaned! We both know how important it is for you to dress to impress when you're out and about.

CHAPTER 8

BEACH BABE

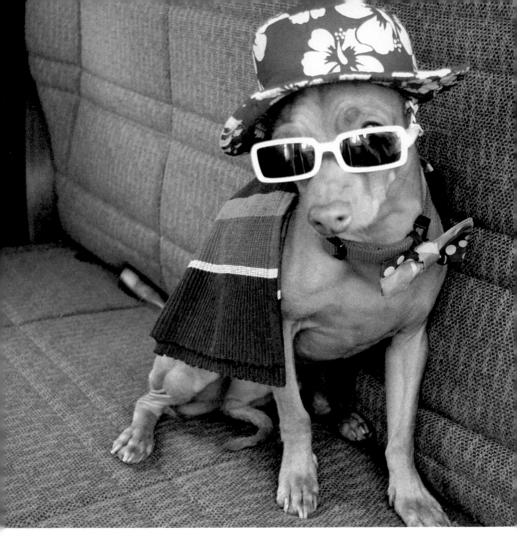

While I can appreciate you wanting to show up to the beach appropriately dressed, I think that you may have gone a little overboard. How about you ditch the accessories so you can cut loose out there and have some fun? But keep the bow tie. It enhances your handsomeness.

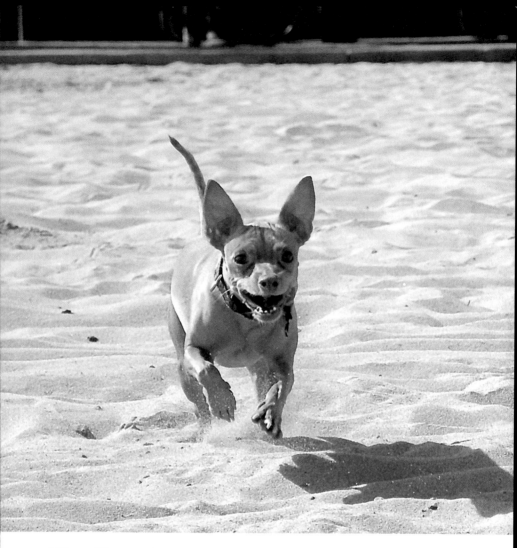

Whoa! You aren't wasting any time, are you? Now, if only you had a rescue buoy and a red swimsuit, you'd fit in perfectly as a *Baywatch* babe, minus the bow tie, of course.

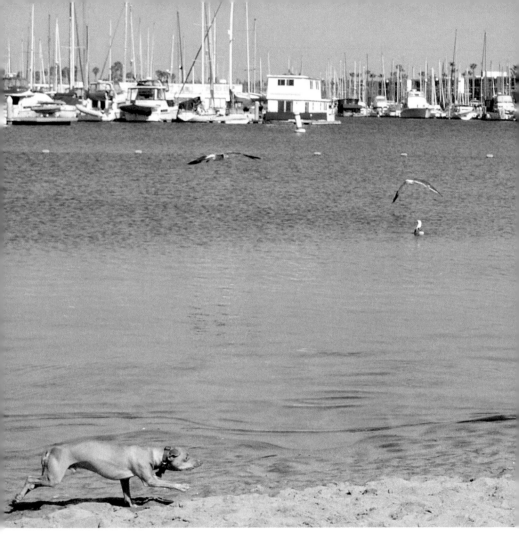

Aah! I should have known better. There's no one to rescue. . . . You're after the birds!

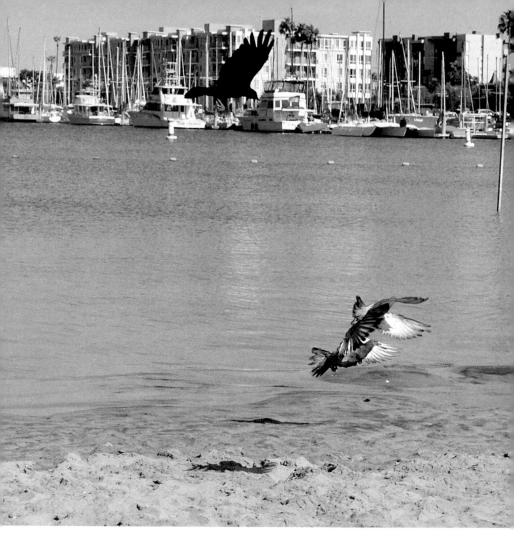

Hey! I'm sure that those birds don't appreciate you chasing after them at full speed! Please keep that in consideration, sir!

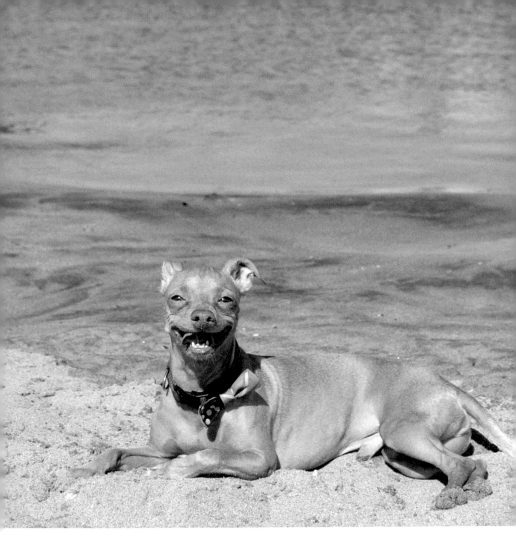

Trying to catch up to other animals that are way faster than you is exhausting, isn't it? How about you sit there and cool your jets for a few minutes?

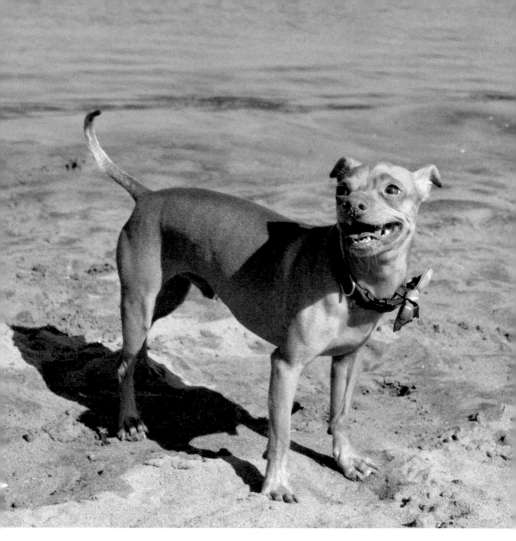

OK, now that you've gotten that out of your system, let's go check out what's happening at the lifeguard station. P.S. You have some sand on your nose, and I thought I should tell you. I'm just trying to help you avoid any future awkward encounters.

Well. Well. Well, sir. Look at you strutting up that ramp all sassy. Work it!

or The Latest Information on
ach Advisories, Water Quality,
her Conditions, Upcoming Events
Public Announcements, Visit:

ATCHTHEWATER.ORG

What do you see out there? A mermaid, you say? I hate to break it
to you, but I think you may be seeing things. If you're convinced,
though, how about you come back down so we can take a closer
look?

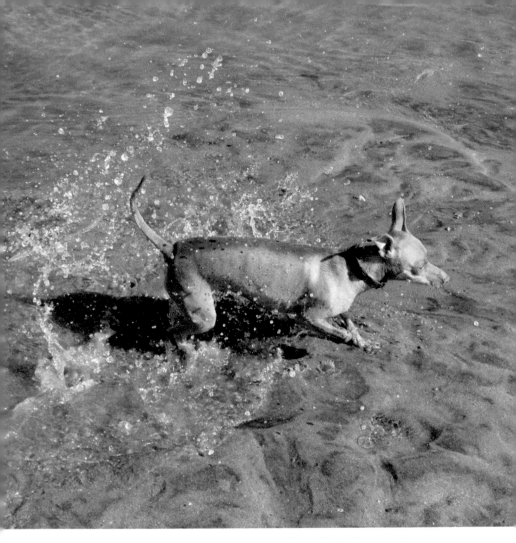

I'll be darned! When I said, "Take a closer look," never in a million years did I expect you to actually touch the water since we both know your true sentiments about it.

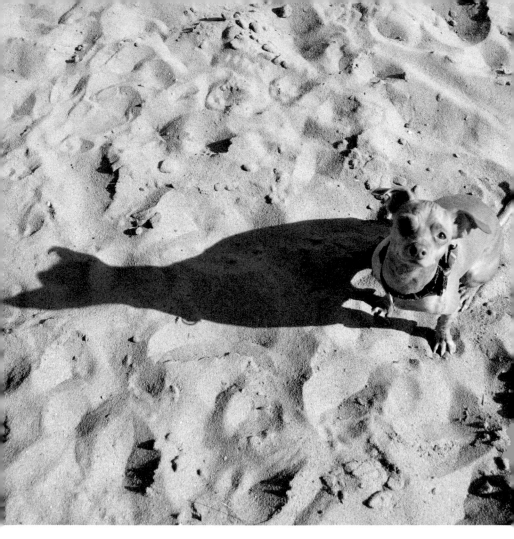

Oh geez! Your tie is all dirty now. I'm not really sure what's gotten into you today. If I'd known that you'd suddenly developed an affinity for the water, I would have removed that lovely accessory from around your neck first. Now, let's find a spot in the sun to dry off.

Are you purposely trying to look like America's Next Top Model?
'Cause it's working. I'll grab my camera!

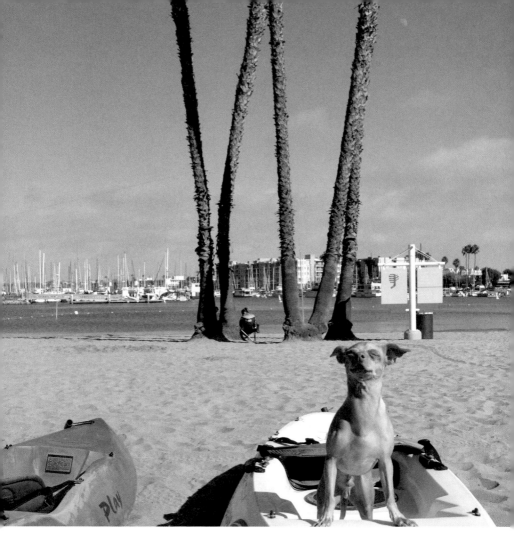

OK, guy. Now you're just showing off. I get it. You're really pretty, but enough with the poses. We have to get going because we have someone special to visit.

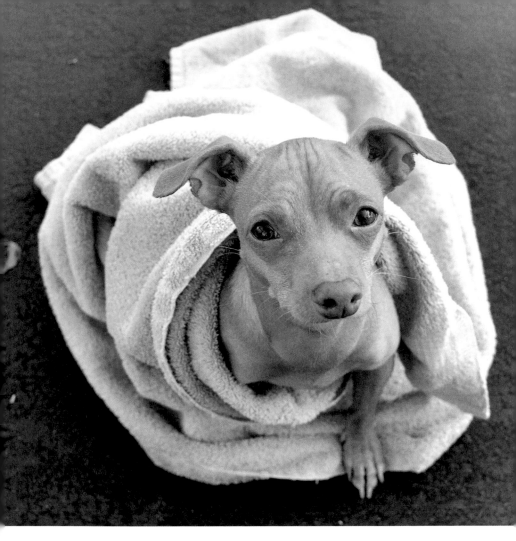

I know you may not think this is necessary, but trust me, sir, it is. Remember the last time we came to the beach, and I didn't wipe you down afterward? Yeah, that's right. I accumulated an entire sandbox in my backseat. Ain't nobody got time for that.

CHAPTER 9

PUPPY LOVE

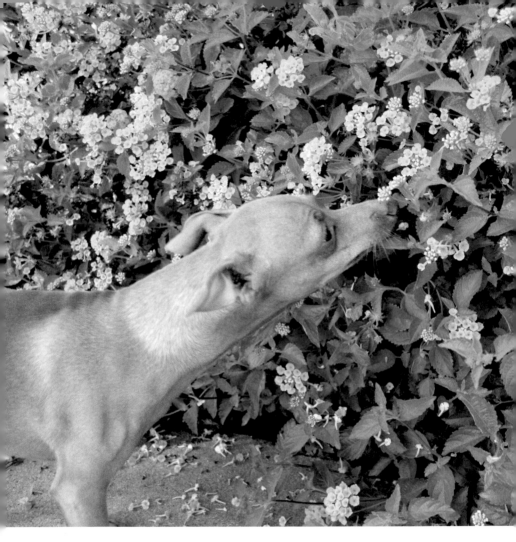

That's so sweet of you to suggest bringing flowers to your girlfriend, Fiona! Such a thoughtful gentleman. So what do you think? Do those smell nice enough for her?

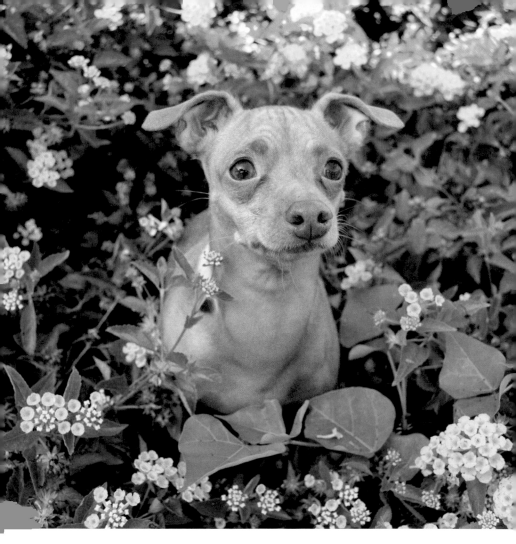

Oh, OK. Or go *in* the flower bushes to find the best ones.
Whatever you prefer.

So you need a little scent spruce-up before seeing Fiona, do you?
Well, typically, that would be a grand idea, but for Pete's sake,
man—in the grass?

I realize that you've been romping around in the smelly ocean, but do you really think that combining the scent of fish and mulch is going to help your cause? Think about it.

It's been a while since you've seen your girlfriend. I take it you're whispering sweet nothings in her ear, aren't you?

I know what you're thinking: Someone needs a breath mint. I couldn't agree with you more, especially if you plan to give her a smooch later.

Whoa! Looks like she beat you to it! Fiona is putting the moves on you first. This Frenchie is appropriately living up to her breed's name with a kiss like that.

Dang, Tuna! That must have been some smooch! Looks like you're ready for round two.

Cute couple alert! Cute couple alert!! Someone call *US Weekly* immediately! Watch out, Brangelina: There's a new power couple in town.

Olan Mills called. They want their pose back.

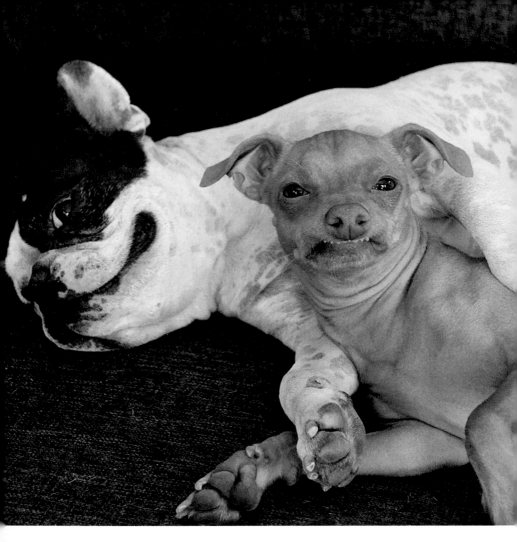

Eh-hmm. Okay, lovebirds. Pardon me for interrupting your cuddle session, but we need to get going, Tuna.

CHAPTER 10

FAKEY FAKEY

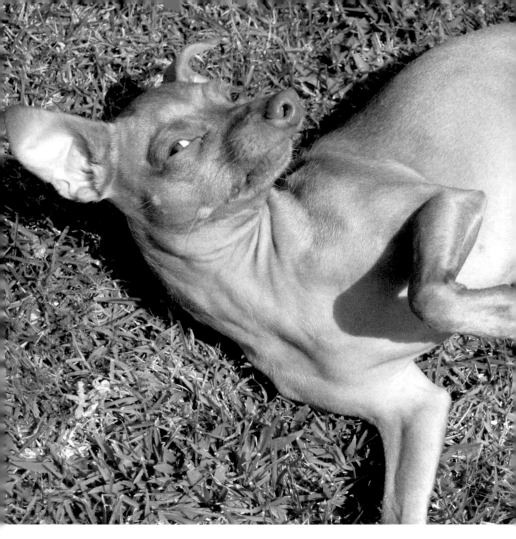

What's with the attitude, Mr. Crankerson? Looks like somebody needs a nap after that playdate. You seem a little annoyed that I dragged you out of there so abruptly.

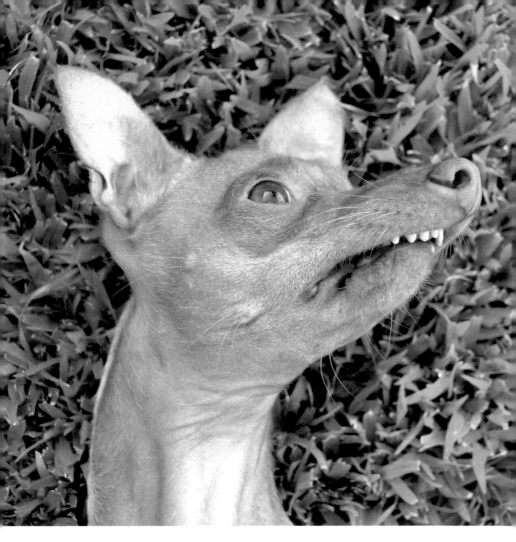

Hey, you! It's rather impolite to turn your head away from me as I'm speaking to you. You heard me. Inside for a nap. Pronto!

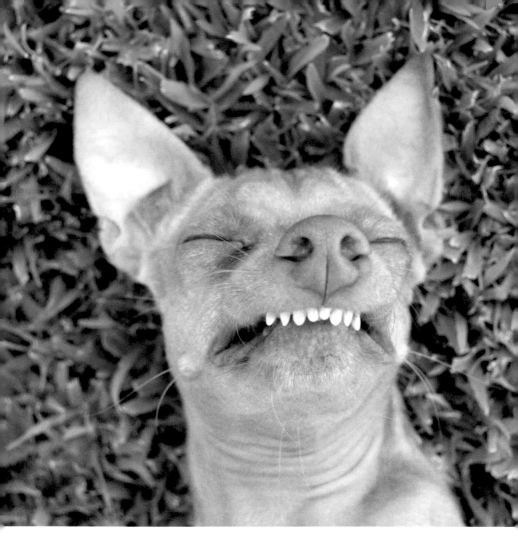

OK, guy. I'm not buying it this time. It's physically impossible to fall asleep in less than a second, even if you do have narcoleptic tendencies. I suspect this is your typical "I can hear you but I'm choosing to ignore you" face. Am I correct in that assumption?

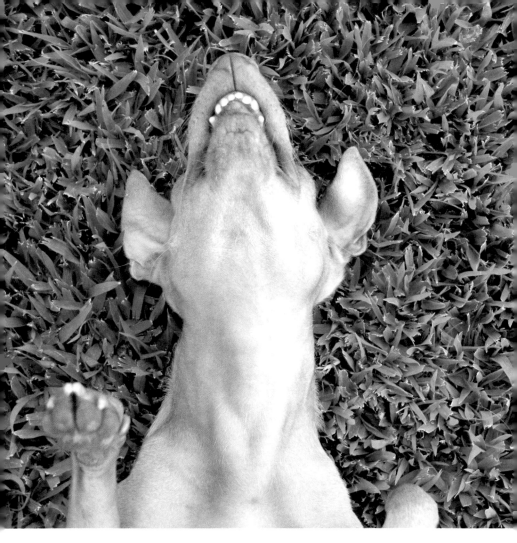

Yep. That's the face, all right. You're definitely ignoring me. Real nice.

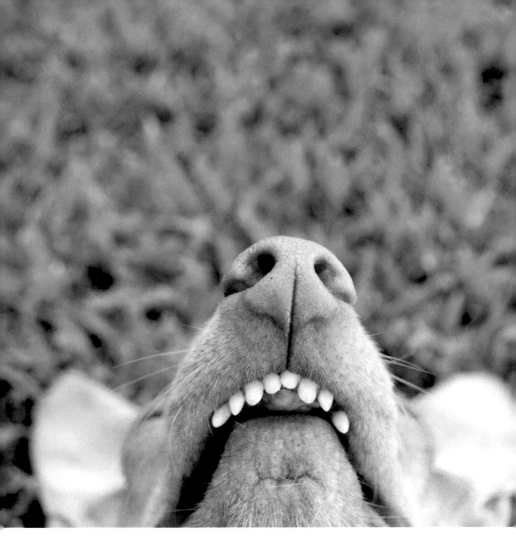

Sir. Excuse me? Sir?

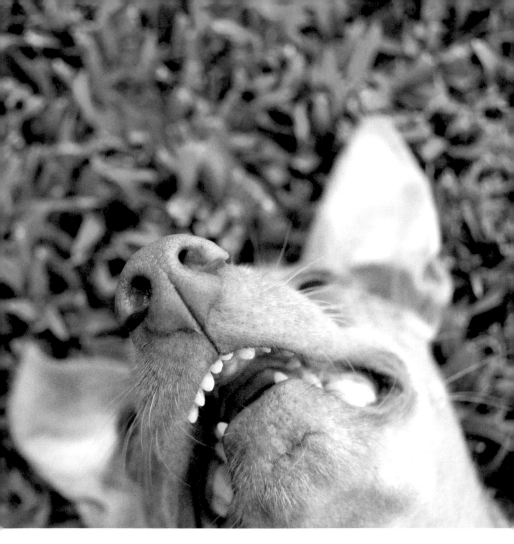

Fine. Ignore me, but since I can see you blatantly smirking at me with your eyes open, I'll just make sure to give you the longest bath of your entire life when you're ready to get up, so please, by all means, take your good ol' time!

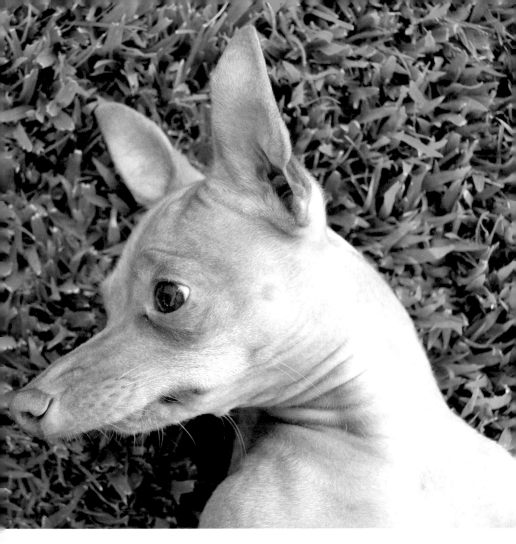

I knew that would get your attention, but unfortunately I'm being serious. I hate to be the bearer of bad news, but it's time to hop in the bath after a full day of getting filthy.

CHAPTER 11

PLAYTIME

Ah yes! The good old stalling technique. Well, just to clarify, I said "bath time," not "playtime." I can almost guarantee that you heard me loud and clear, but maybe you have too much water in your ears from the beach.

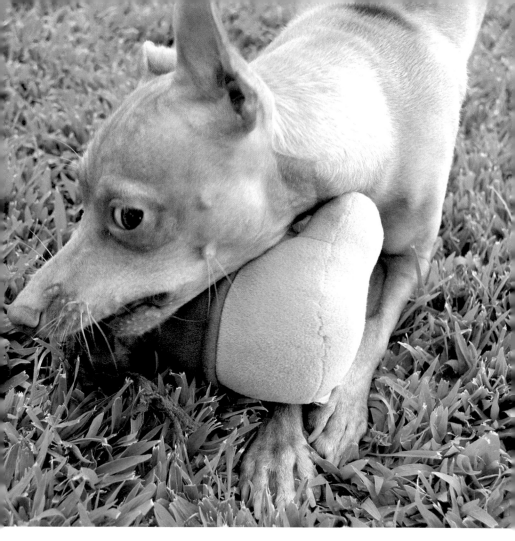

Well, looks like his fate is sealed. Maybe I should start calling
New Colin "The New 'Old' Colin"?

That's quite impressive that you're able to toss him up in the air like that so effortlessly. Have you ever considered trying out for the cheerleading squad?

Whoa, sir! Forget cheerleading. It looks like you're more interested in taking up interpretive dancing, based on those fancy footsteps. I thought that we were about to play fetch, not samba.

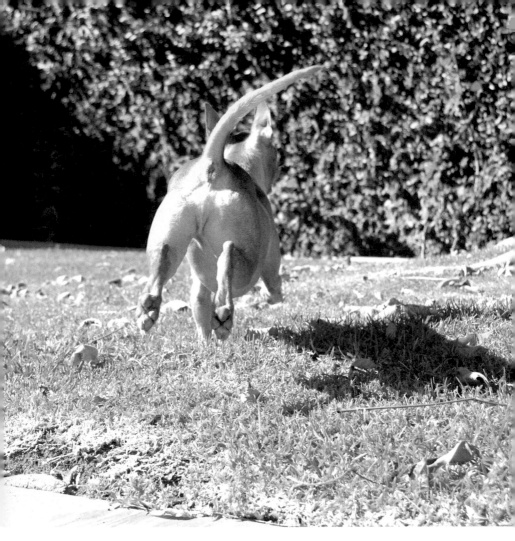

While it's been absolutely thrilling to watch you play with New Colin in the same patch of grass for the past ten minutes, it's a nice change to see you actually run after him. Supposedly that's the entire concept behind fetch, but what do I know? Since you're the dog, you're the expert.

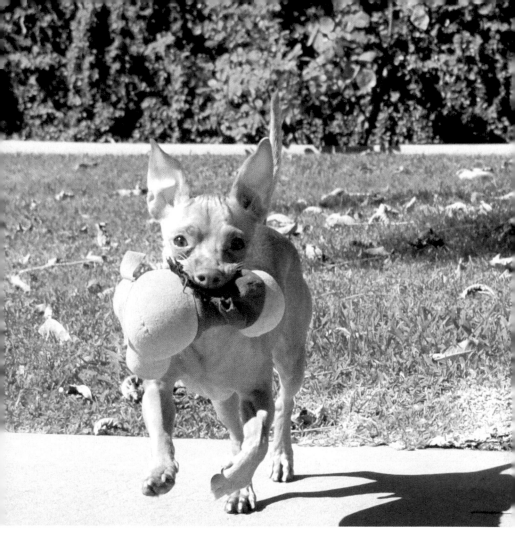

Well, aren't you just the cutest little golden "retriever" that I've ever seen? I mean, you're more gingery than you are golden, and you're a Chiweenie, not a Retriever, but you get what I mean.

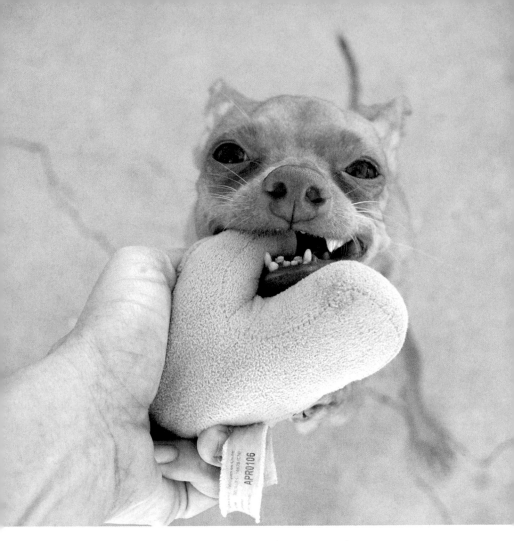

OK, guy. You can get his foot out of your mouth now. No more stalling. You've done enough of th . . .

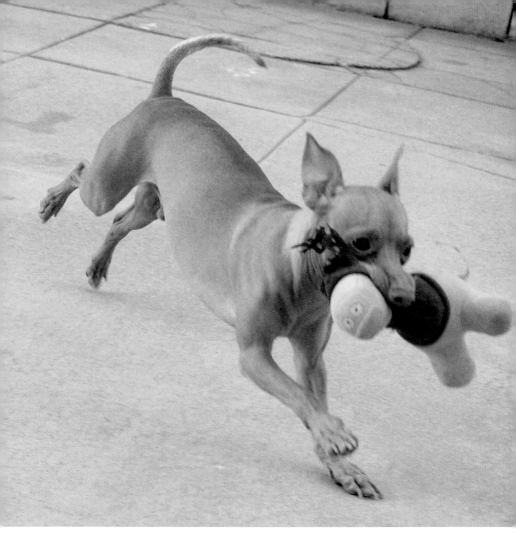

Hey! Get back over here, you little sneak. You're acting like this is the first time that you've played with a toy today. Let me remind you, sir. You've played with both Colins close to a hundred times. OK, fine. I may be exaggerating a bit, but trust me, it's been a lot.

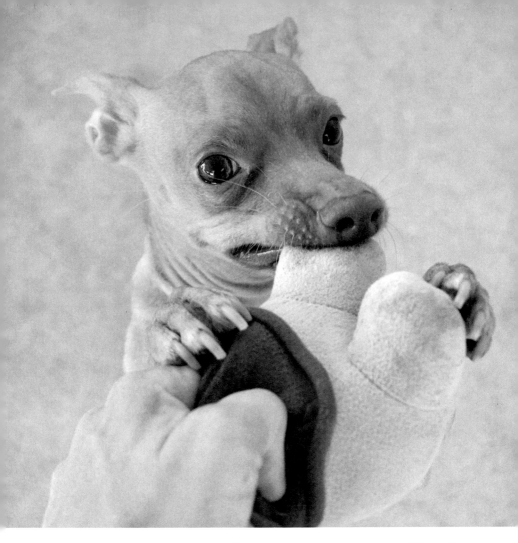

If you're unwilling to let go, how about we compromise? I'll trade you Colin for a cookie. I love how I have to bribe you to get you to do what you're supposed to, as in take a bath.

CHAPTER 12

COOKIE TIME

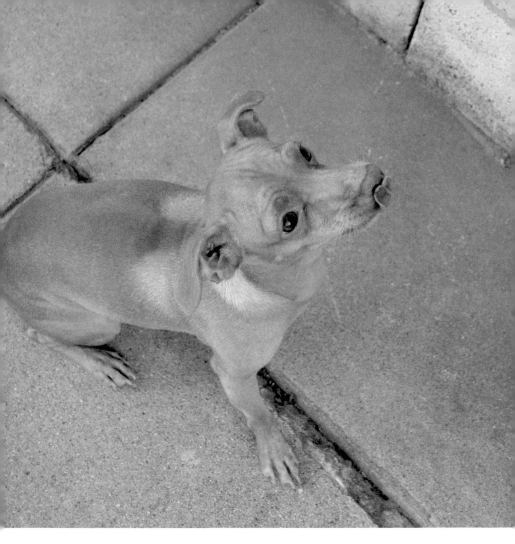

I'm so glad that you agreed to that exchange. It's a pretty good trade off, isn't it? I mean . . . just look at how delicious this looks!

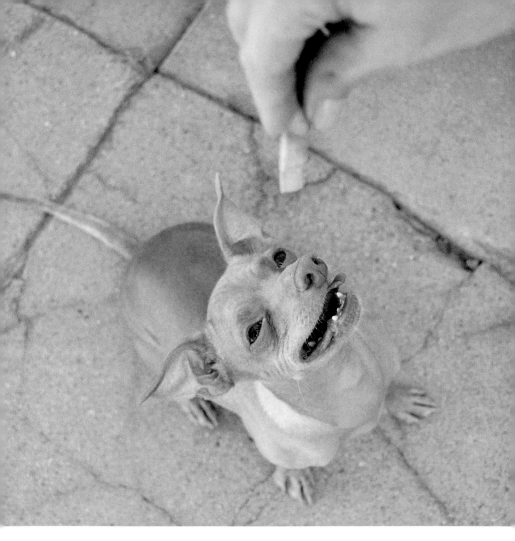

Well, guy, you have two options here: You can either sit there for a lifetime, imagining how amazing the cookie in my hand tastes, or you can do that impressive cookie waltz of yours and find out for yourself. It's totally your call. No pressure.

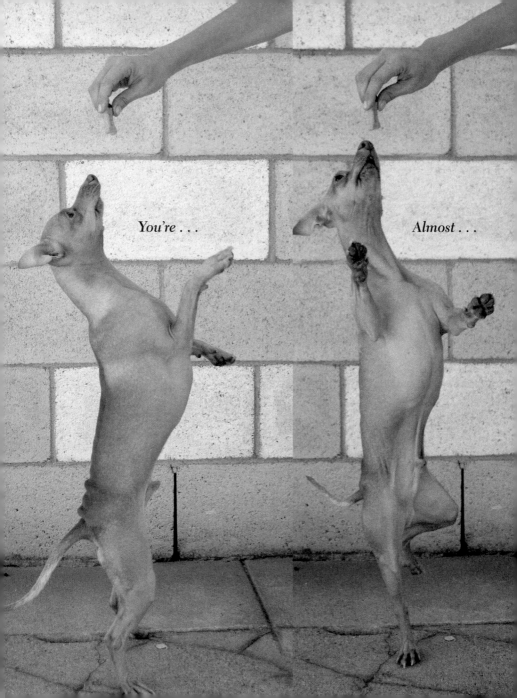

You're . . . Almost . . .

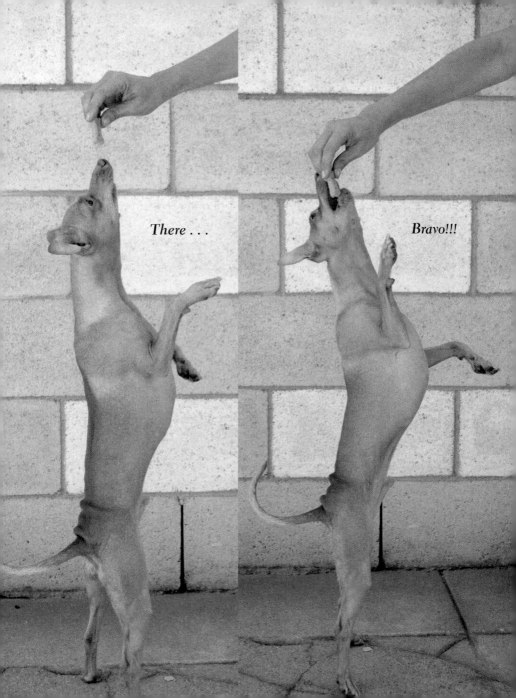

There . . .

Bravo!!!

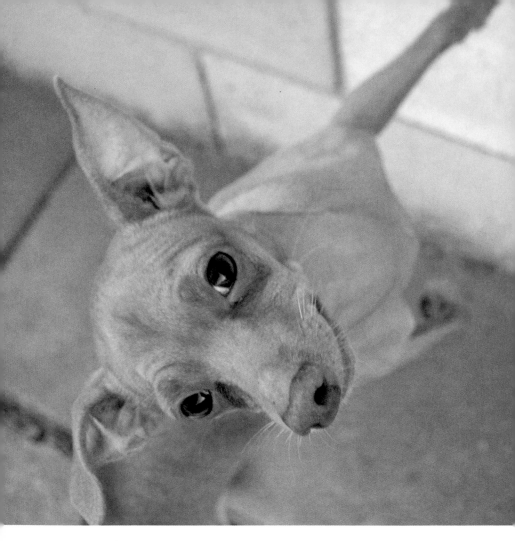

Want another cookie? Wait. Who am I kidding? Of course you do! Why am I even asking you that? Duh.

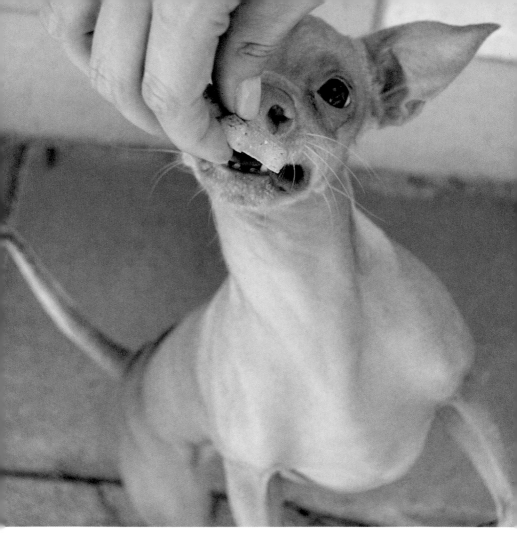

Remember what I said earlier. I need that hand, which includes those fingers.

Yes, sir. That's the last of it, but I can guarantee that staring at it for a long period of time isn't going to preserve your stock. You might as well just eat that crumb.

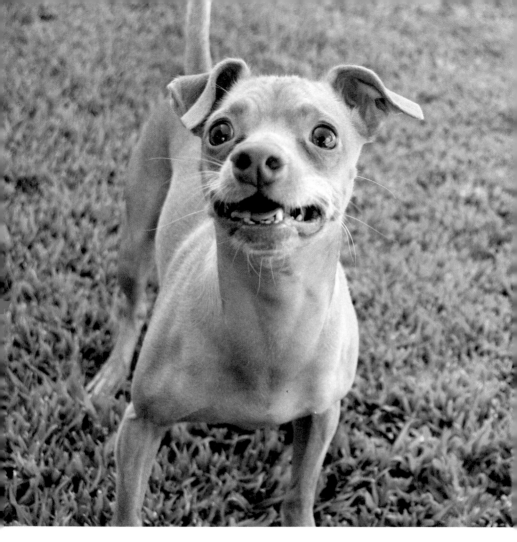

Oh fine. Your groveling earned you one more, but that's it.
Remember that I'm going to have to get out the big bad
toothbrush if you eat too many.

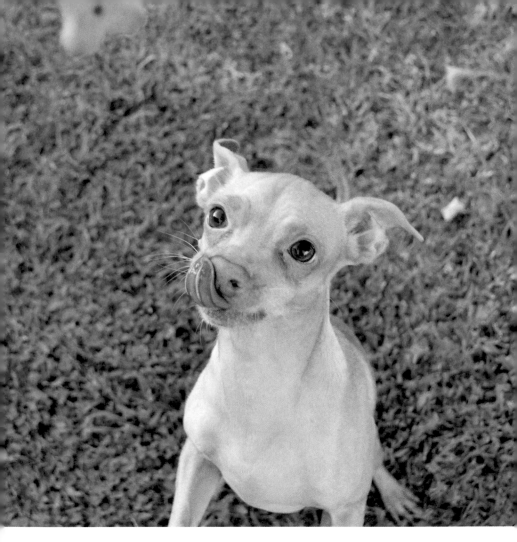

You certainly have a one-track treat mind. From the looks of that tongue, you'd think you've never tasted a cookie before, but let me remind you . . . you just had several, so . .

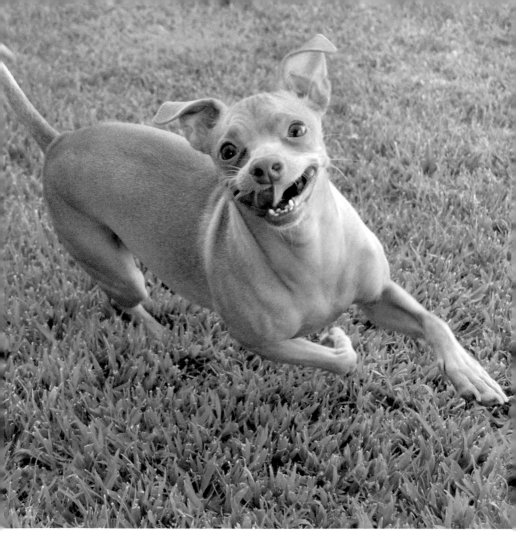

Ah! Getting in your evening exercise, I see. There you go. Run off those cookies that you just consumed.

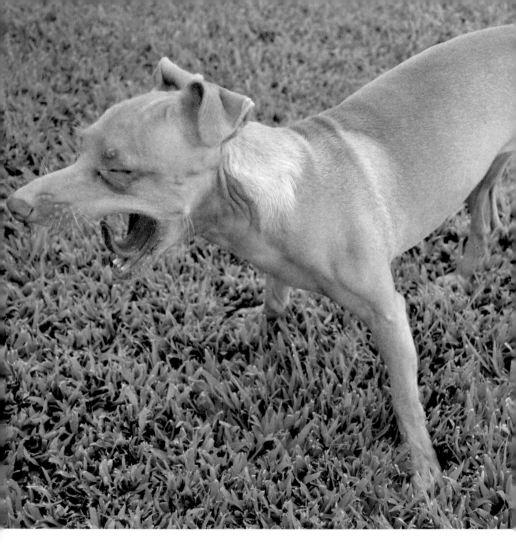

Looks like someone is experiencing what's referred to as a sugar crash. That'll happen after an overload of treats. Lucky for you, I have just the thing that will wake you up right away, and it's not a coffee, so don't get any wild ideas.

CHAPTER 13

BATH TIME

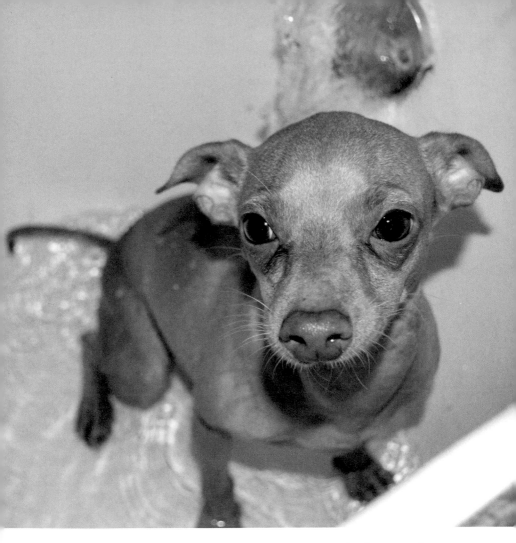

I'm sorry, sir, but unfortunately this was what I had in mind. I realize that water isn't an ally of yours, but after we wrap this up, trust me, you'll be thanking me for the major scent improvement.

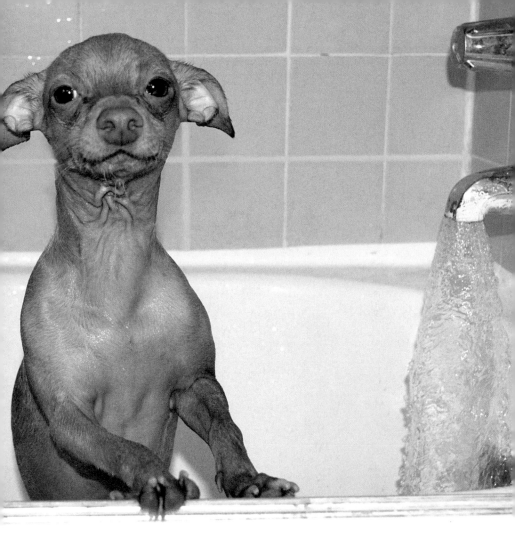

It appears like you're protesting this bath, but there's no escaping this now, mister. You're committed to this activity for at least the next five minutes. Maybe three if I can get your full cooperation.

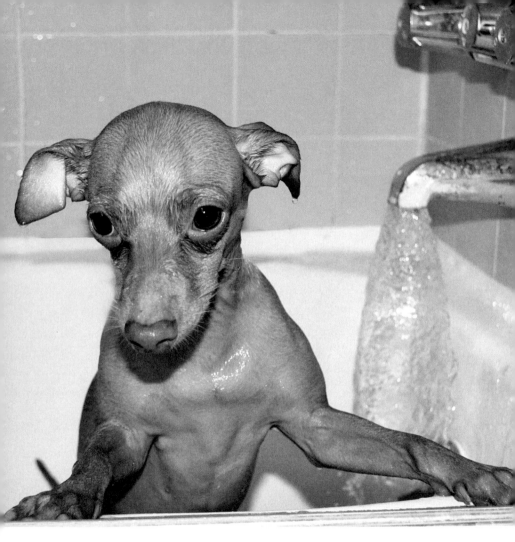

Don't look so glum, guy. It really isn't that bad. Besides, water
looks good on you, so you can sit back down now.

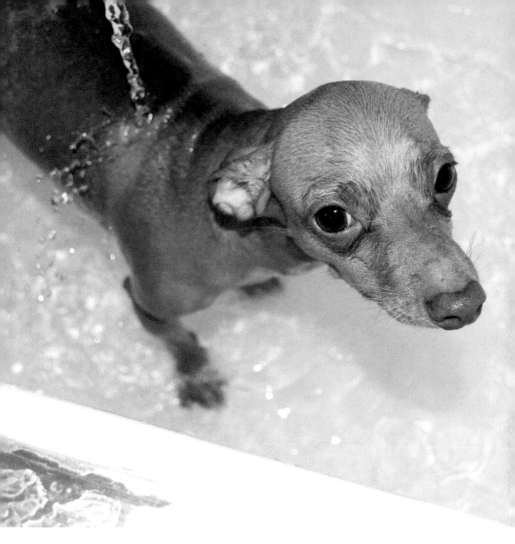

Also, I was under the impression that you're keen on water after
your brave demonstration at the beach earlier this afternoon.
Look. It's touching you, and you're not even flinching! Good job!

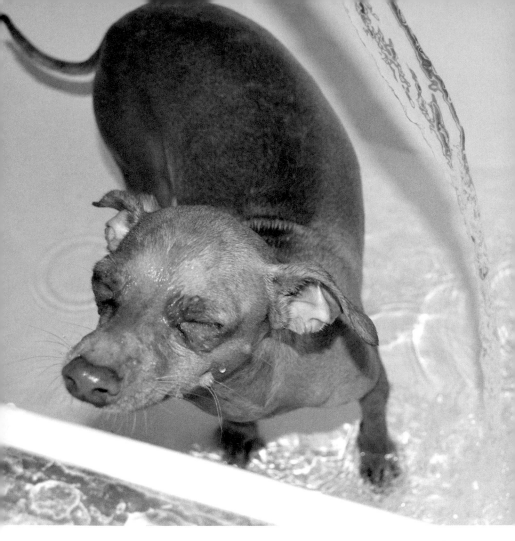

I guess I spoke too soon. Don't you think that you're being a little overly dramatic? The water is nowhere near you.

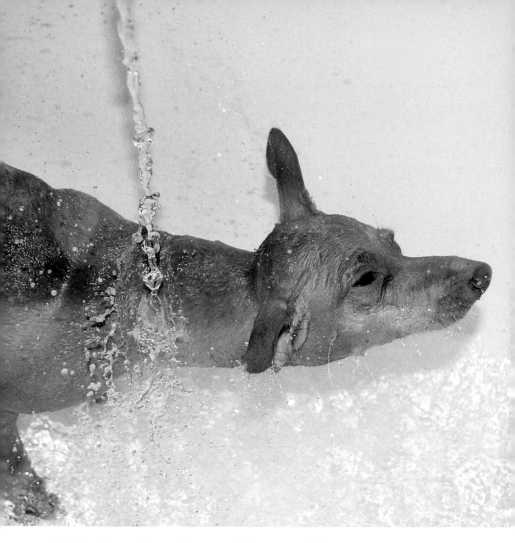

You're almost done, but I would suggest shaking off the water *after* I've finished pouring it on you. Trying to dry off now kind of defeats the purpose.

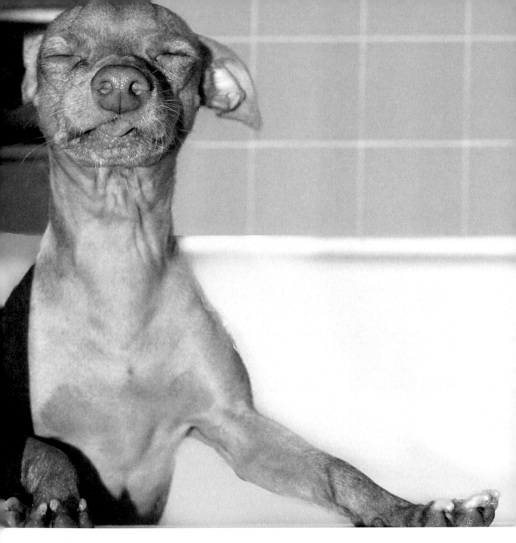

All done! Either you're sticking your tongue out at me to send a message that you're not happy about bath time, or you're just downright relieved now that it's over. I'm choosing to go with the latter.

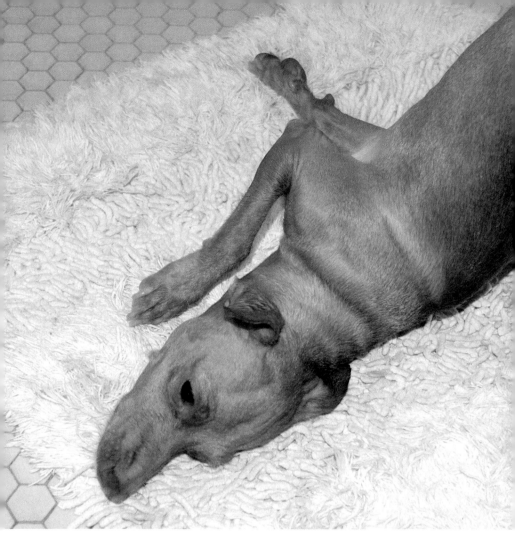

Sir, while I can appreciate your desire to want to dry off immediately, the bath mat that I step on every day is not the solution. Why don't we get you a clean towel instead since its sole purpose is to remove the water off of your body?

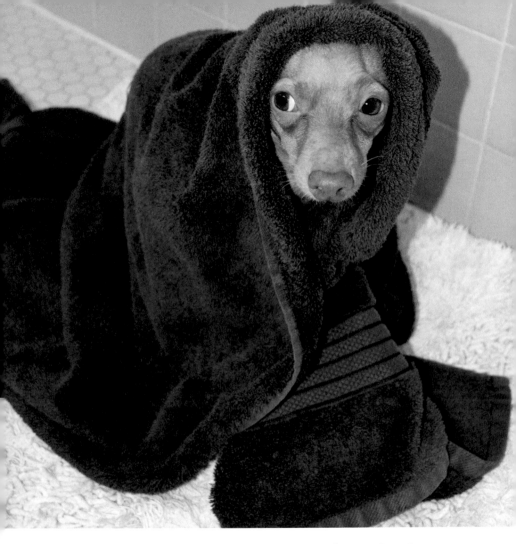

You're wrapped up like up burrito again! You know what that means. Bedtime!

CHAPTER 14

STORY TIME

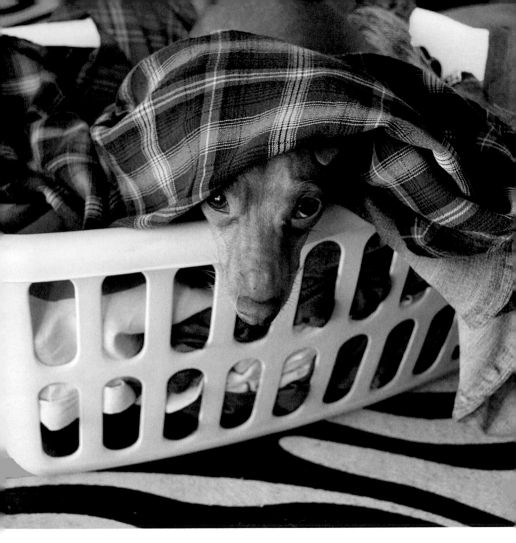

OK, buddy. You can come out from hiding under the dirty laundry now. Otherwise you may need another bath. Hop up in bed, please, because I'd like to tell you a fascinating story before you go to sleep.

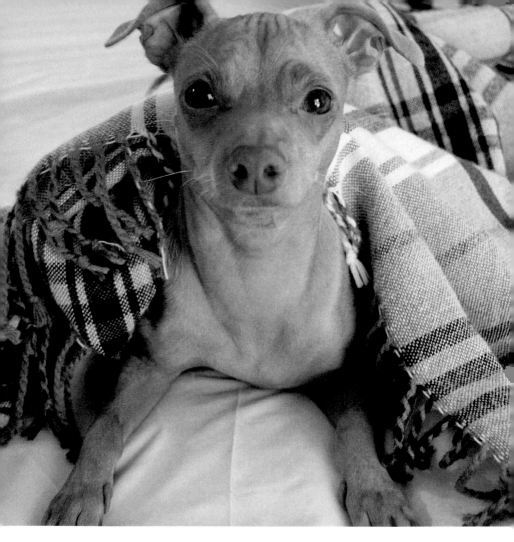

Thank you. Now that I have your full attention, I shall begin.
Once upon a time, there was a magnificent little puppy who was
born with a purpose. He might not have known it at the time, but
he was created to do some incredible things in his life.

He was separated from his real parents at a young age, and when he was just four months old, he met a new mommy, who promised to love him with excellence. She was first introduced to him at a farmers' market where he was being shown for adoption.

When she took him home, this little puppy hardly had any of his teeth. Little did they both know that his teeth would be one of his most special attributes. For it would be through his unique smile, among many of his other charming qualities, that he would capture the hearts of millions of people.

Her little puppy was so adorable and always made her laugh, so
for fun, she started taking photos of him to capture his most
endearing moments.

instagram Meet Tuna (@tunameltsmyheart), this Monday's #weeklyfluff! This little guy is a "chiweenie"—part chihuahua, part dachshund —with an incredible, and incredibly endearing, overbite. Follow along to make Tuna a part of

After their first wonderful year together, she decided to start sharing her photos of him on a social media site called Instagram. A year after posting those photos, Instagram featured three pictures of her puppy on their official page, unbeknownst to her.

Suddenly, her puppy was getting love and attention from people all over the world! They appeared on television shows. He was featured in articles and attended fun events to help support animal rescue. None of this was ever anticipated or expected by his mommy, but she was grateful to be a part of it all.

Whenever I am in a bad mood and look at pictures of Tuna, I am **instantly uplifted.**

Tuna helps me every day with my self-esteem and he always brings **extra happiness** to my day!

Tuna has made me **smile** when nothing else could.

A photo of Tuna can turn **a bad day into a good one.** Thank you for shining his light on thousands of people

Tuna is teaching **kindness, compassion and love** to all creatures!

Tuna has been **a great distraction** from cancer.

Although Tuna is so small, he has such **a big impact on my heart!**

It's amazing how a silly little guy like Tuna can bring me **so much joy.**

You see, she realized that her unconventional-looking puppy was making a huge impact on people globally, and that pleased her so much! She was more than happy to share the joy that she received from her puppy because she knew that he was being used as a catalyst to change people's days, perhaps even their lives.

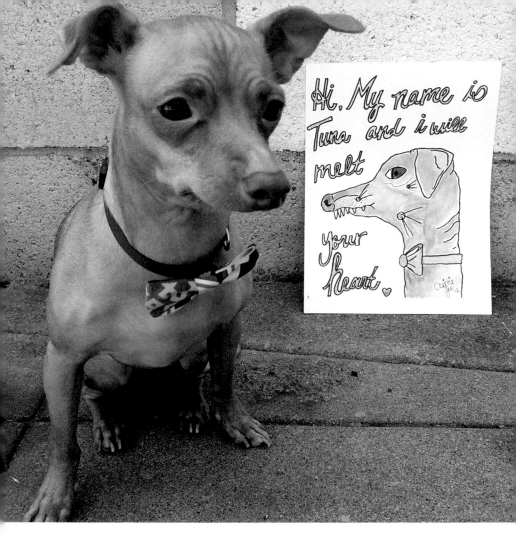

So, my darling . . . that was his purpose: to change perspectives about beauty and to melt people's hearts. And he did both of those things extremely well. The end.

CHAPTER 15

BEDTIME

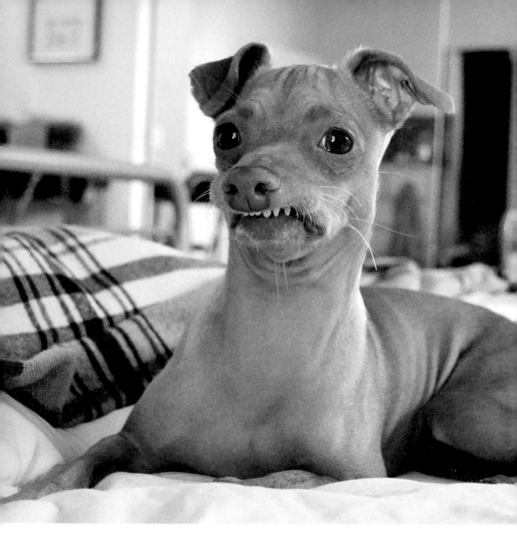

I must say, you look a little surprised, guy. Doesn't that story sound familiar to you?

The story is about you! Super cool, right!? You don't seem that impressed, but you should be! You melt so many people's hearts, including mine. That's why I told you this morning just to be your awesome self because you melt my heart most of all when you do that.

The fact that you're falling asleep in the middle of me talking to you is super classic and just melts me! I'll take the hint, though, and I'll stop doting on you. Let's get you in your pj's so you can curl up in the covers.

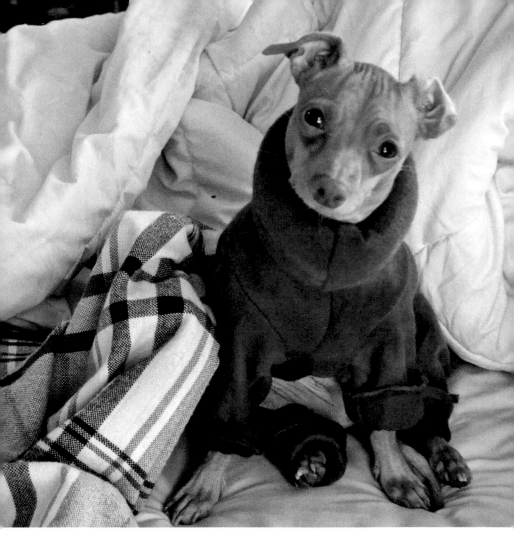

Since being warm is so important to you, you're guaranteed to be cozy now that you have on your adorable fleece turtleneck onesie. You literally look like a tiny stuffed animal in it, and I could squeeze the stuffing right out of you!

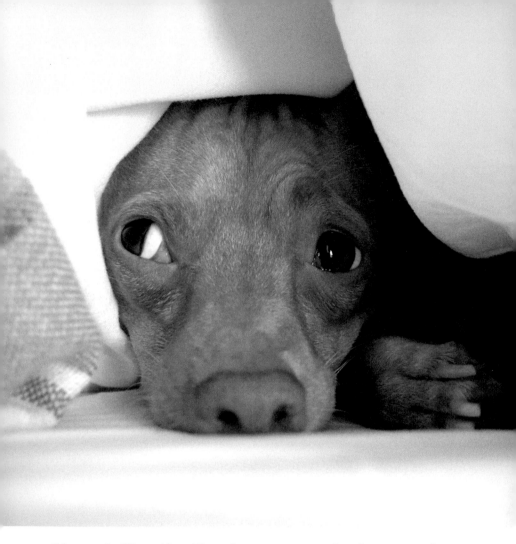

I have a brilliant idea. How about you get under the covers, where you love to be, and you can go to sleep? Does that sounds like a good plan to you? I feel like I'm getting a yes from your right eye.

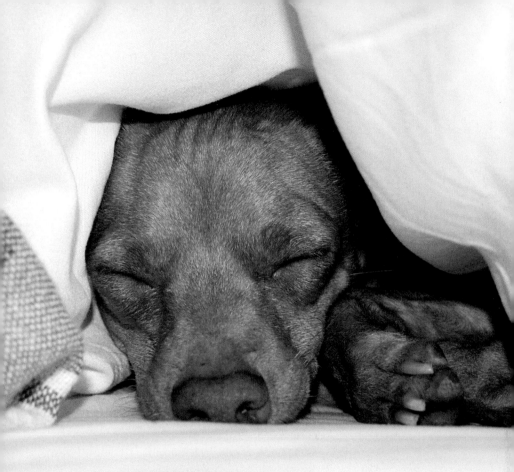

OK, great! I'm glad that you agree! Good night, my sweet, sweet little toodlebrain. Thank you for melting my heart all day today, and I'm looking forward to you doing it all over again tomorrow.

THE

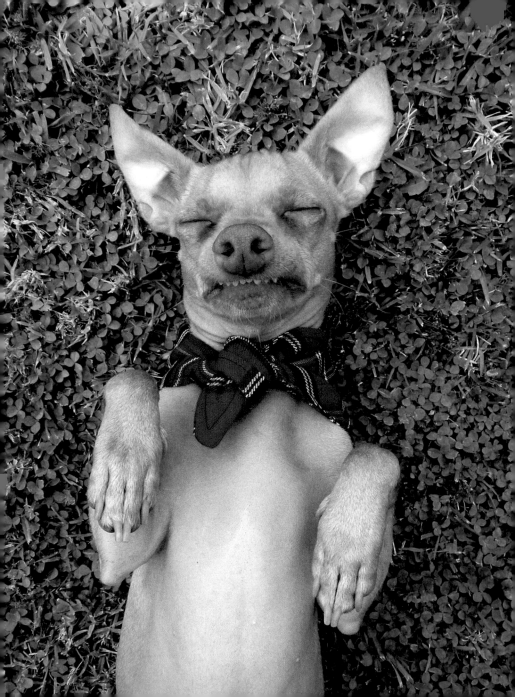

ACKNOWLEDGMENTS

Tuna. You are the greatest joy in my life and I adore you. Thank you for always making me laugh and for being such a good sport. You rescued me more than I rescued you because you helped redefine my purpose.

Kara Dykert. You have been the greatest manager, encourager, helper, supporter and cheerleader. I appreciate everything you have done with and for Tuna and me. Thank you for seeing my potential, and for pushing over the domino. I treasure our friendship.

Courtney Friedman. You have been an incredible best friend to me, and an amazing auntie to Tuna. I love how much he adores you and cousin. Although distance separates us, thank you for always being here for me, especially when I need grammatical confirmation and/or correction. ;)

Tanaz Pourshalmi. Thank you for helping me raise Tuna the first year of me having him. You were such a huge help and I am indebted to you.

Dan Toffey. If you hadn't featured Tuna on Instagram's #weeklyfluff, not as many people would know about him. I always credit you with putting him on the map . . . literally.

Matt Vaughan. Thank you for being such an amazing uncle and dog-sitter, especially when I travel for extended periods. As I always say, I really appreciate you.

Uncle Vic & Fiona. We are so grateful for you both!

Grandmerms and Pappy. You are the best parents to me, and grandparents to Tuna. Thank you for letting me soar!

All of his Aunties and Uncles. You know who you are and Tuna is wild about you.

Leesa Mayer. Thank you for believing in me and for loving me with excellence. You are

a valued friend and mentor in my life. I cherish you.

Jen Schuster. You made this book process a cinch. Thank you for being such a great coach!

Robin Faber. Thank you for rescuing so many dogs in need. You do such great work for the animal community. I consider you Tuna's first rescue mom since you took him in before I ever met him.

Naomi Kobrin. In our eyes, Bronze is a hero for "retrieving" (old) Colin. Thank you for returning him to us.

Monster Factory. Thank you for creating Colin. Your dolls are amazing, and you should really consider coming out with a dog-specific line. It would do really well. ;)

Ruby Rufus Isaacs. You are a genius designer. Thank you for all of the gorgeous Ruby Rufus cashmere sweaters that you have gifted Tuna over the years.

To everyone who has ever sent Tuna gifts, or who has drawn Tuna. You are all amazing!

To my Heavenly Father. Without your favor, none of this would be possible. That I know to be undoubtedly true. Thank you for taking my dream to change the world, and making it a reality.

Last but not least, to all of Tuna's loyal followers from all over the world. I take none of you for granted. Your love, support and friendship are the reason I continue to share Tuna's adventures with all of you. Thank you for making this fun and worthwhile!

ABOUT THE AUTHOR

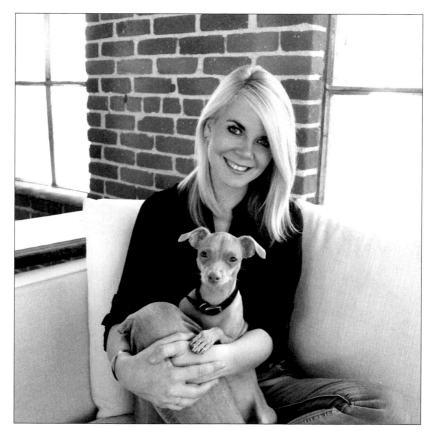

Tuna's mom, **Courtney Dasher**, is an advocate of animal rescue, and she is committed to bringing her audience joy through Instagram and Facebook. She has given Tuna a voice for the underdog and built a loyal following for @Tunameltsmyheart. Courtney and Tuna live in Los Angeles.